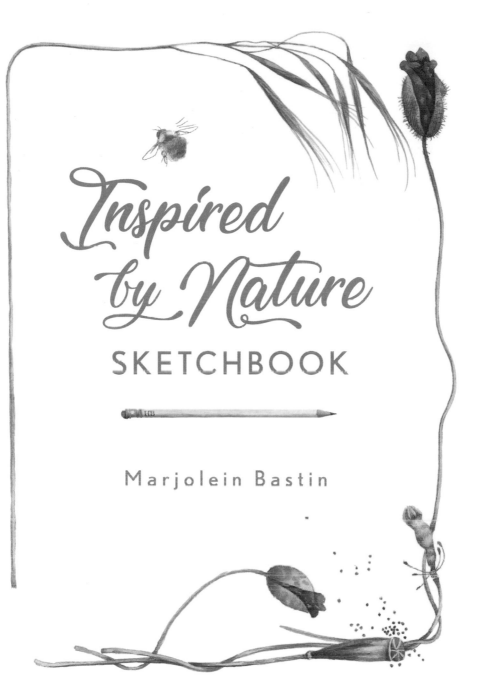

Inspired by Nature

SKETCHBOOK

Marjolein Bastin

Andrews McMeel
PUBLISHING®

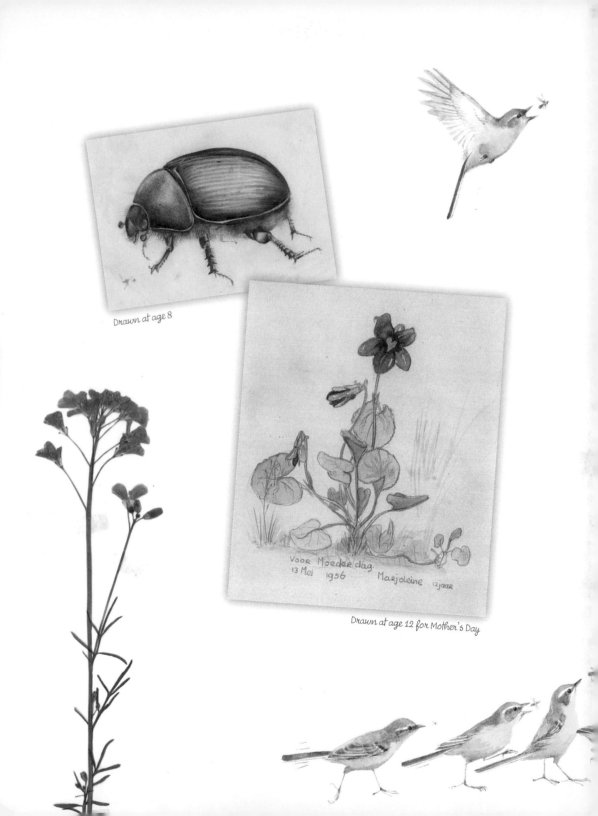

Drawn at age 8

Voor Moeder dag.
13 Mei 1956 Marjoleine 12jaar

Drawn at age 12 for Mother's Day

Dear artist, nature lover, dreamer—

My sketchbooks are an unfiltered view into my heart;
a reflection of what fascinates me in nature. For decades,
I have traveled all over the world with sketchbooks,
filling them with experiences, observations, and nature
finds. The word sketchbook may be a bit of a misnomer;
it feels more like a private diary. To see my sketches
here, side-by-side with the finished art, is both thrilling
and a little unnerving.

The entries in my sketchbook are an important link
in my creative chain. They are unfiltered and spontaneous, not carefully planned and
thought-out compositions that are sometimes necessary for the finished artwork. When
I go back through my sketchbooks later, I immediately feel the original emotional
impulse that motivated me to sketch.

If that impulse is strong enough, I will sooner or later decide to make a painting.
The sketchbook is always invaluable because it contains the initial spark I felt when
I witnessed something in nature that I wanted to retain forever. That spark is what
I try to capture in my artwork.

All my sketchbook entries remind me of the sense of wonder I felt when something in
nature caught my attention. It is my hope that the empty pages in this book inspire you
to capture moments in nature that are significant to you. Draw, paint, or collect.
This sketchbook is open to anything.

Marjolein Bastin

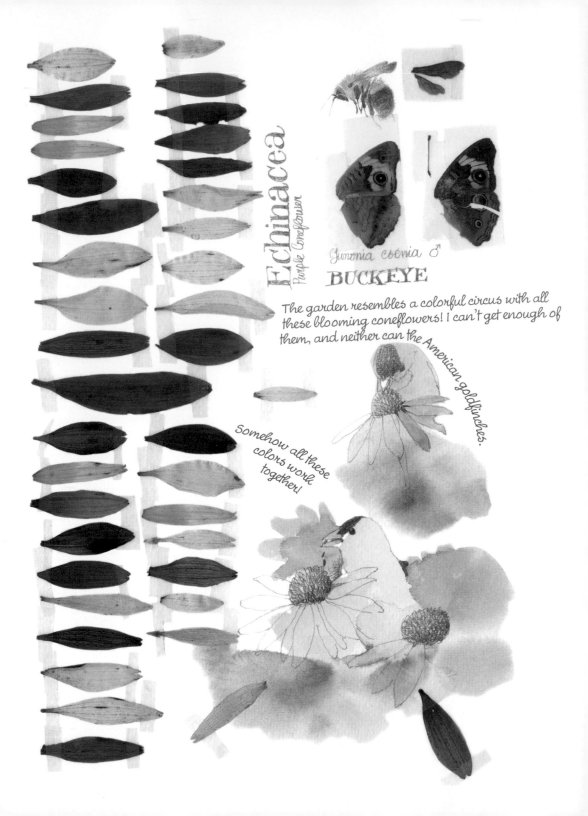

Echinacea
Purple Coneflower

Junonia coenia ♂
BUCKEYE

The garden resembles a colorful circus with all these blooming coneflowers! I can't get enough of them, and neither can the American goldfinches.

Somehow all these colors work together!

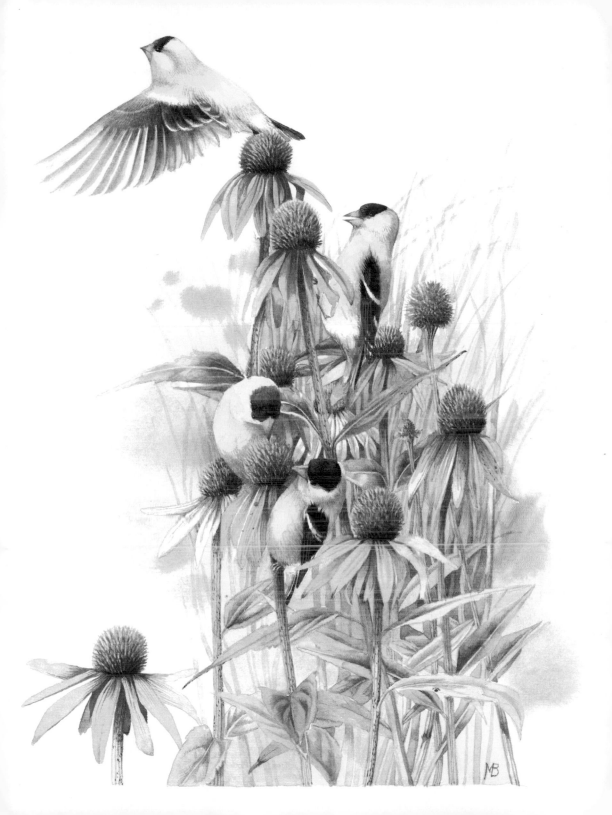

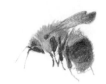

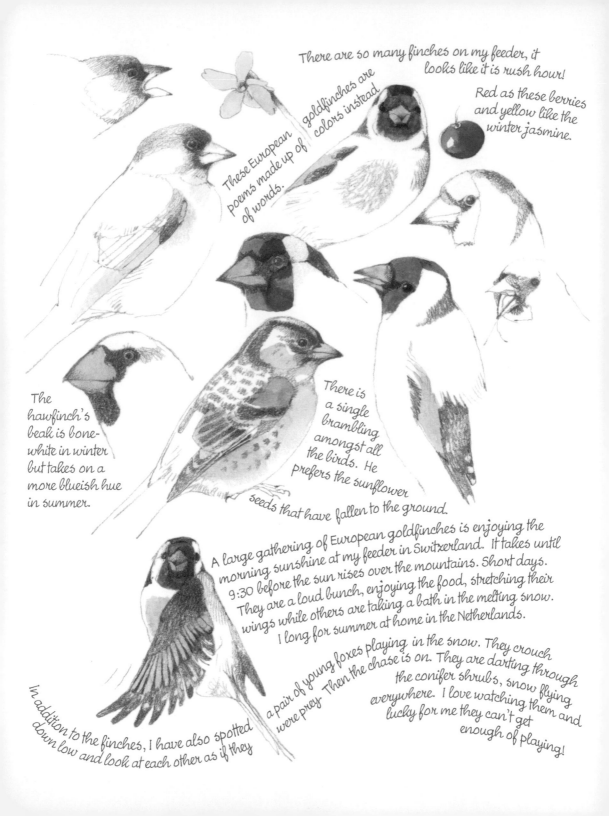

There are so many finches on my feeder, it looks like it is rush hour!

These European goldfinches are poems made up of colors instead of words.

Red as these berries and yellow like the winter jasmine.

The hawfinch's beak is bone-white in winter but takes on a more blueish hue in summer.

There is a single brambling amongst all the birds. He prefers the sunflower seeds that have fallen to the ground.

A large gathering of European goldfinches is enjoying the morning sunshine at my feeder in Switzerland. It takes until 9:30 before the sun rises over the mountains. Short days. They are a loud bunch, enjoying the food, stretching their wings while others are taking a bath in the melting snow. I long for summer at home in the Netherlands.

In addition to the finches, I have also spotted down low and look at each other as if they were prey. Then the chase is on. They are darting through a pair of young foxes playing in the snow. They crouch the conifer shrubs, snow flying everywhere. I love watching them and lucky for me they can't get enough of playing!

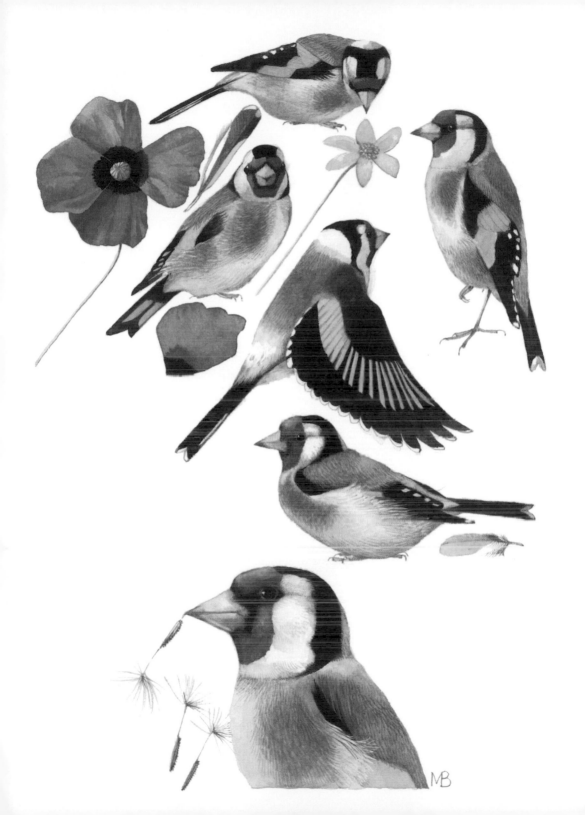

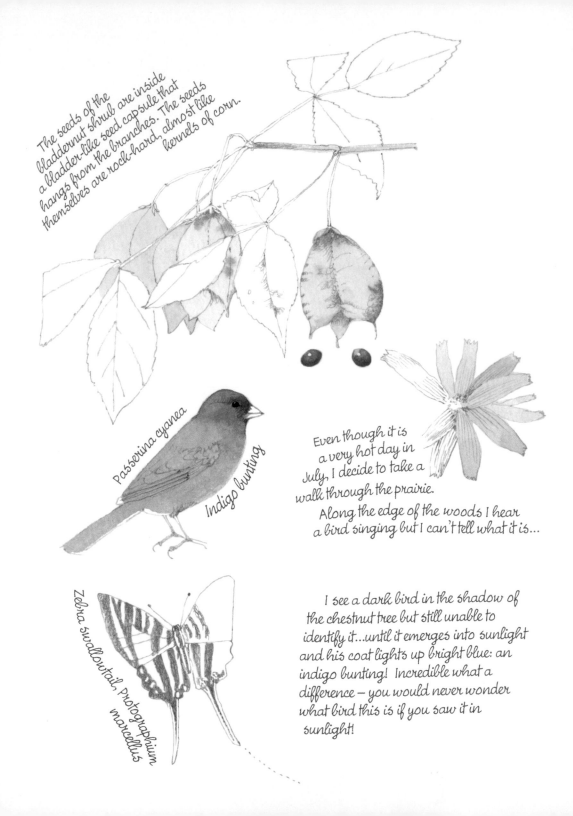

The seeds of the bladdernut shrub are inside a bladder-like seed capsule that hangs from the branches. The seeds themselves are rock-hard, almost like kernels of corn.

Passerina cyanea

Indigo bunting

Even though it is a very hot day in July, I decide to take a walk through the prairie.

Along the edge of the woods I hear a bird singing but I can't tell what it is...

I see a dark bird in the shadow of the chestnut tree but still unable to identify it...until it emerges into sunlight and his coat lights up bright blue: an indigo bunting! Incredible what a difference — you would never wonder what bird this is if you saw it in sunlight!

Zebra swallowtail, protographium marcellus

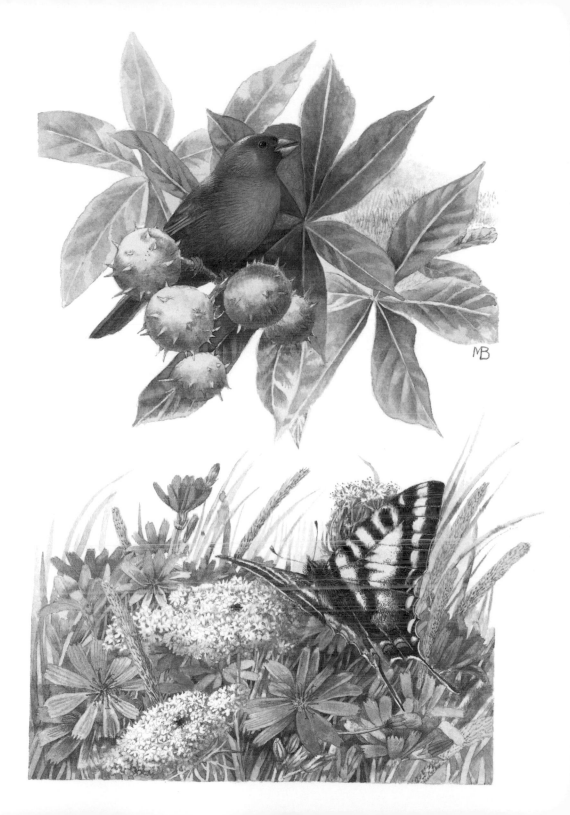

Travel provides a great variety of inspirations for me and for that reason I love observing nature in different countries and climates. But to return home after traveling to a new place is equally rewarding if I'm honest. Perhaps it is the familiarity, or the sense of "home" but I feel so happy when I get to discover my own garden again!

There are countless snail shells on the patio!

The song thrushes find them among the flowers and then crack them open on the patio pavers.

It looks like the barn swallows have been born!

This squirrel is still working on its nest; it should be ready by now!

Every thirty minutes or so he runs by my studio with a mouthful of nesting materials.

Love watching these damsel-flies hover over the pond.

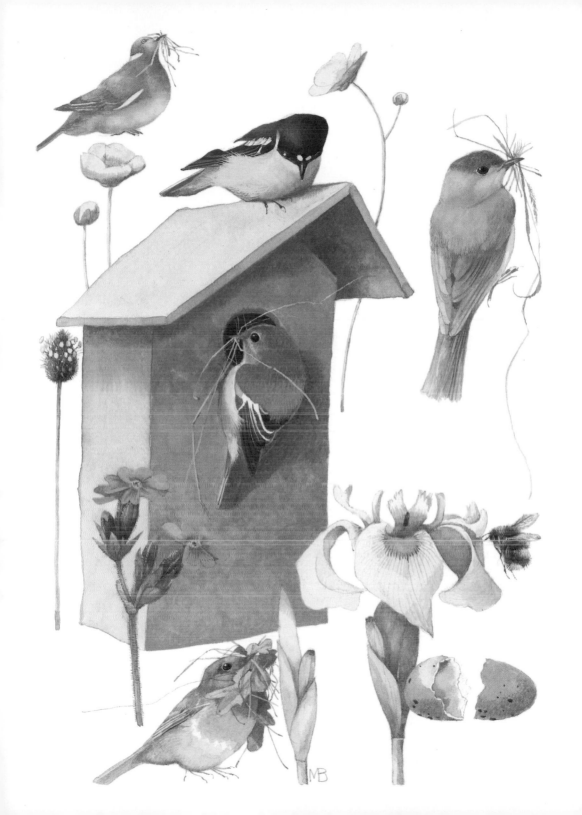

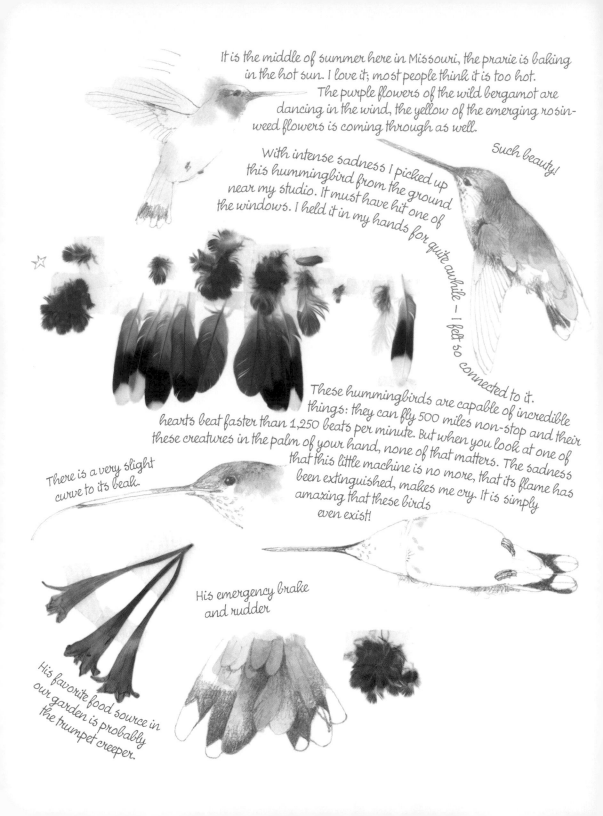

It is the middle of summer here in Missouri, the prairie is baking in the hot sun. I love it; most people think it is too hot.

The purple flowers of the wild bergamot are dancing in the wind, the yellow of the emerging rosin-weed flowers is coming through as well.

Such beauty!

With intense sadness I picked up this hummingbird from the ground near my studio. It must have hit one of the windows. I held it in my hands for quite awhile — I felt so connected to it.

These hummingbirds are capable of incredible things: they can fly 500 miles non-stop and their hearts beat faster than 1,250 beats per minute. But when you look at one of these creatures in the palm of your hand, none of that matters. The sadness that this little machine is no more, that its flame has been extinguished, makes me cry. It is simply amazing that these birds even exist!

There is a very slight curve to its beak.

His emergency brake and rudder

His favorite food source in our garden is probably the trumpet creeper.

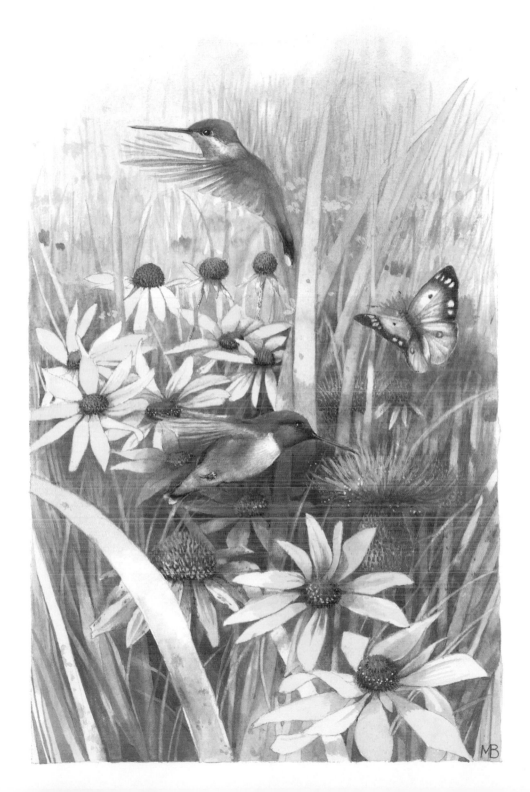

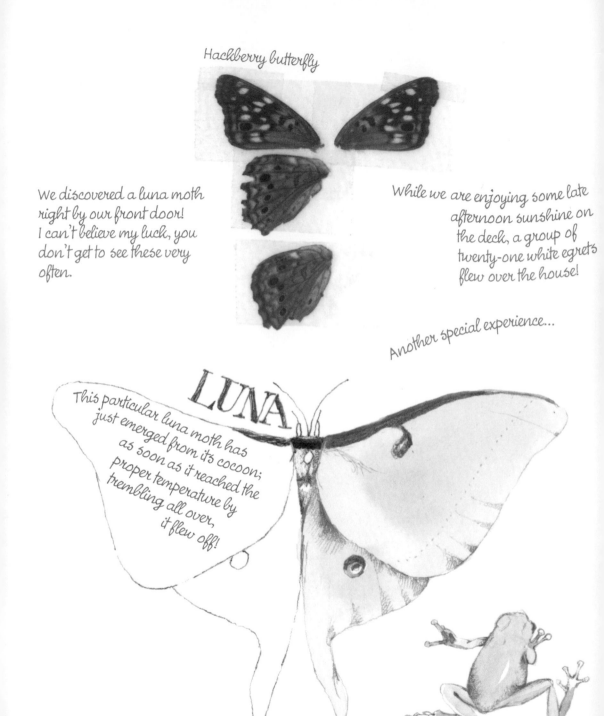

Hackberry butterfly

We discovered a luna moth right by our front door! I can't believe my luck, you don't get to see these very often.

While we are enjoying some late afternoon sunshine on the deck, a group of twenty-one white egrets flew over the house!

Another special experience...

LUNA

This particular luna moth has just emerged from its cocoon; as soon as it reached the proper temperature by trembling all over, it flew off!

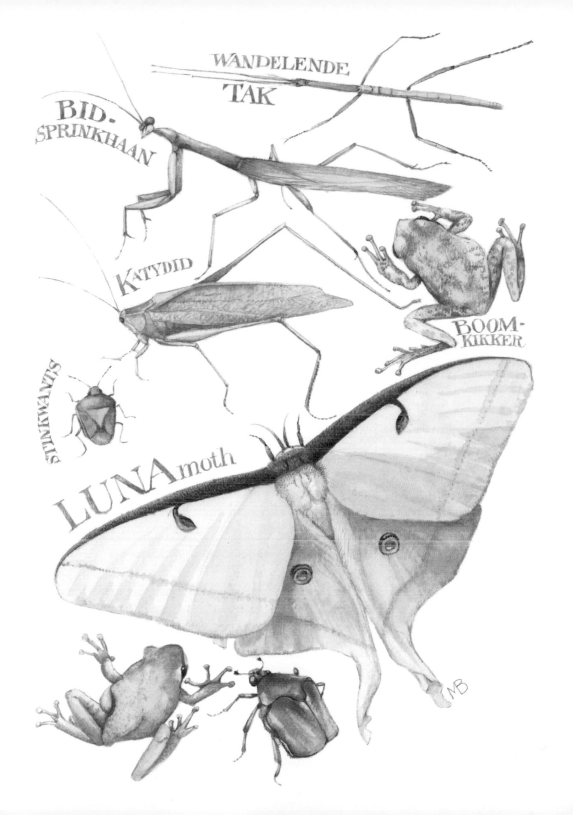

WANDELENDE
TAK

BID-
SPRINKHAAN

KATYDID

BOOM-
KIKKER

STINKWANTS

LUNAmoth

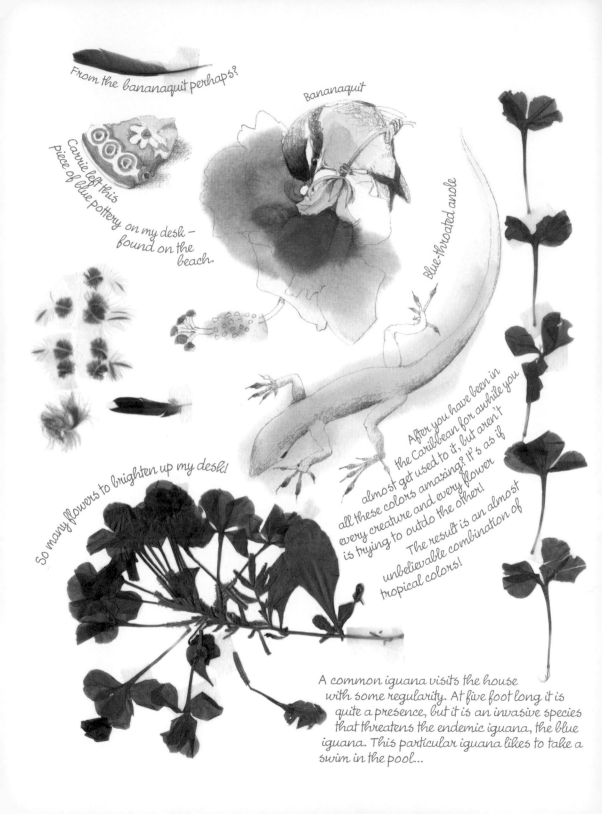

From the bananaquit perhaps?

Bananaquit

Carrie left this piece of blue pottery on my desk – found on the beach.

Blue-throated anole

So many flowers to brighten up my desk!

After you have been in the Caribbean for awhile you almost get used to it, but aren't all these colors amazing? It's as if every creature and every flower is trying to outdo the other! The result is an almost unbelievable combination of tropical colors!

A common iguana visits the house with some regularity. At five foot long it is quite a presence, but it is an invasive species that threatens the endemic iguana, the blue iguana. This particular iguana likes to take a swim in the pool...

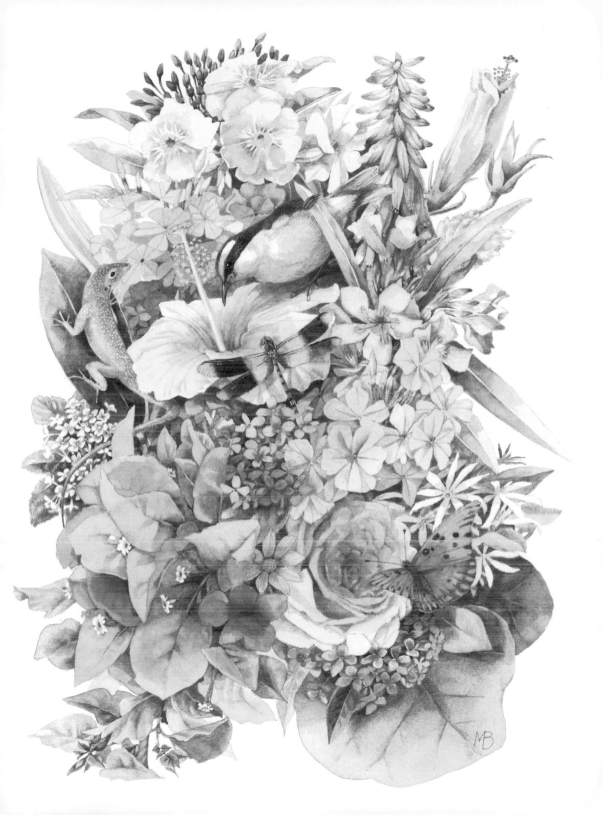

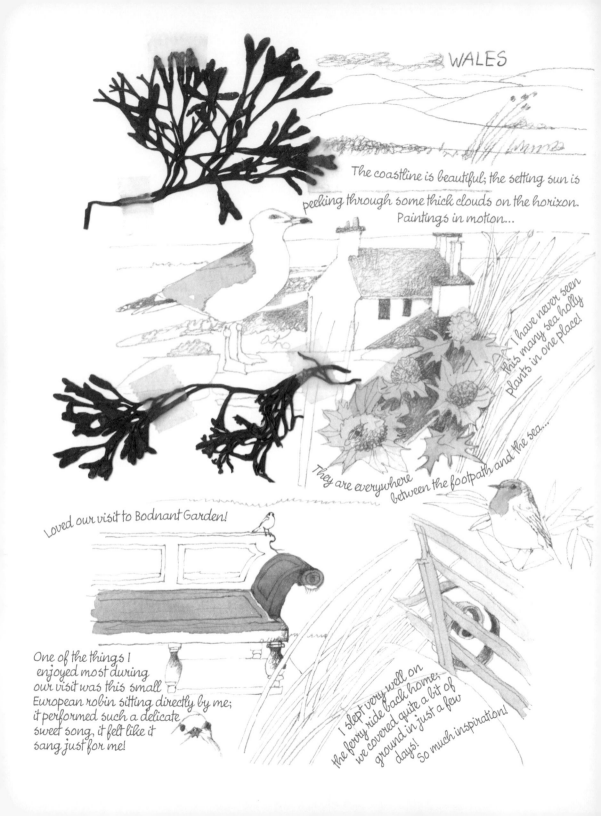

WALES

The coastline is beautiful; the setting sun is peeking through some thick clouds on the horizon. Paintings in motion...

"I have never seen this many sea holly plants in one place!

They are everywhere between the footpath and the sea....

Loved our visit to Bodnant Garden!

One of the things I enjoyed most during our visit was this small European robin sitting directly by me; it performed such a delicate sweet song, it felt like it sang just for me!

I slept very well on the ferry ride back home; we covered quite a bit of ground in just a few days! So much inspiration!

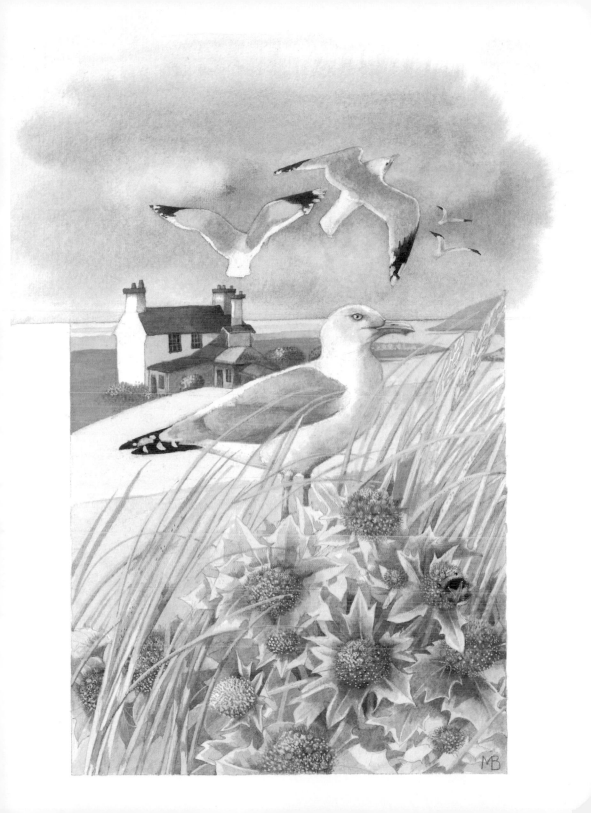

Sitting at my desk I am pretty sure I just saw
something move from the corner of my eye...

A blue streak crossing the pond...

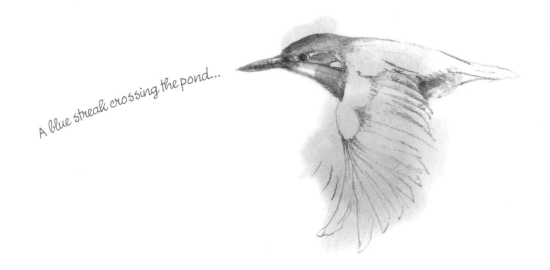

The kingfisher is flying
back and forth between
two of his favorite
perches along the edge
of the pond,
looking for lunch.

The bright blue colors of his
feathers against
the brown and green
hues of the lily pads is quite
striking. I will make this
into a new painting!

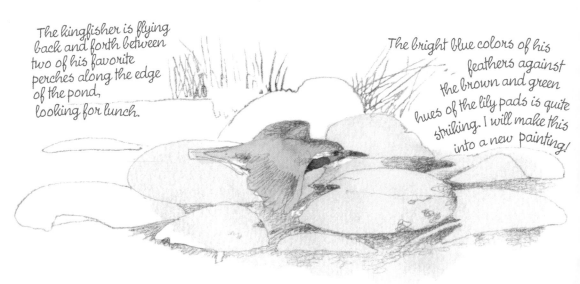

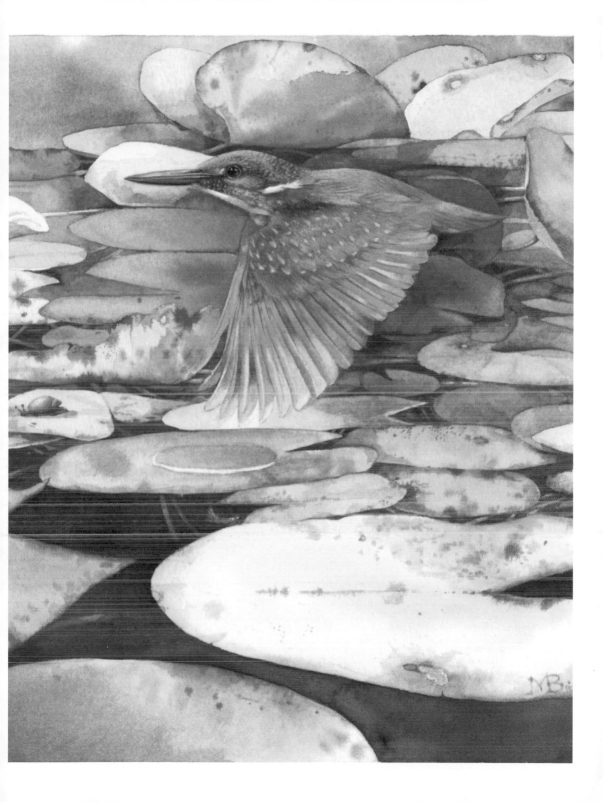

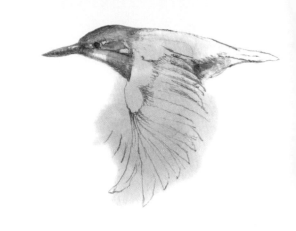

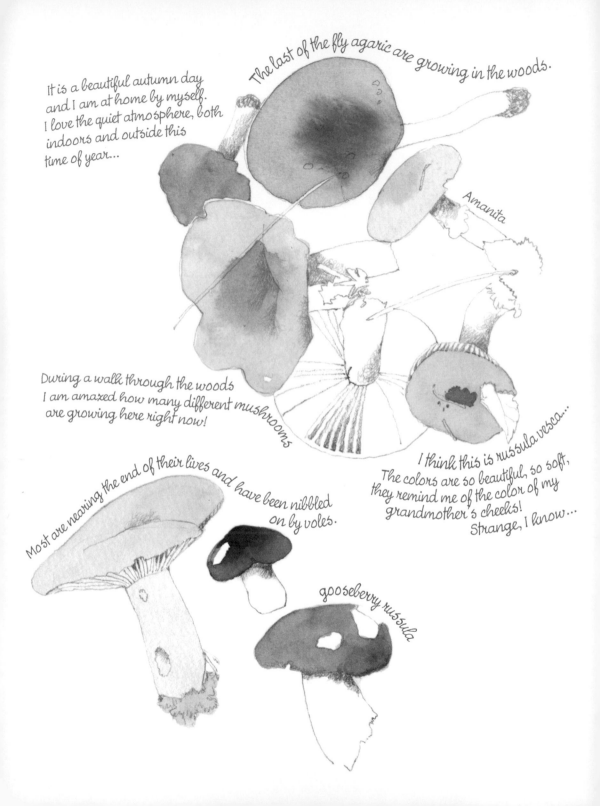

It is a beautiful autumn day
and I am at home by myself.
I love the quiet atmosphere, both
indoors and outside this
time of year...

The last of the fly agaric are growing in the woods.

Amanita

During a walk through the woods
I am amazed how many different mushrooms
are growing here right now!

I think this is russula vesca...
The colors are so beautiful, so soft,
they remind me of the color of my
grandmother's cheeks!
Strange, I know...

Most are nearing the end of their lives and have been nibbled
on by voles.

gooseberry russula

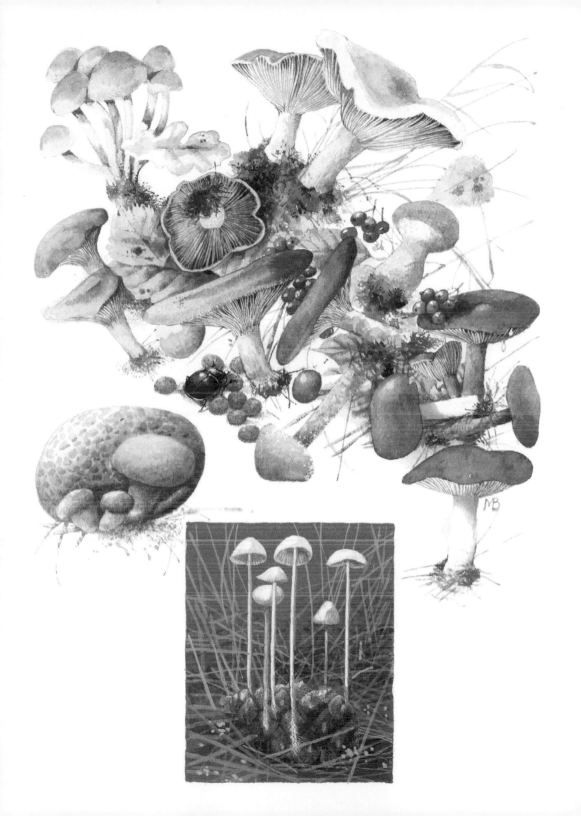

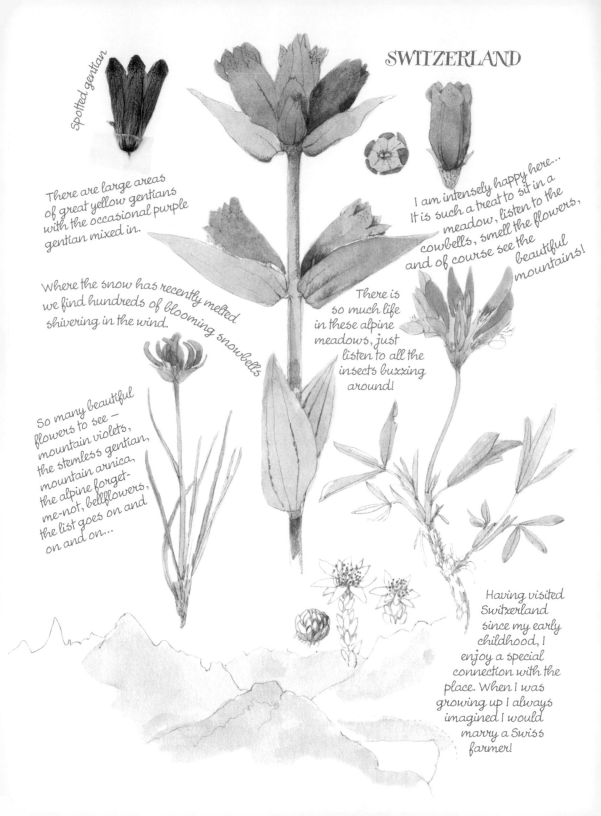

Spotted gentian

SWITZERLAND

There are large areas of great yellow gentians with the occasional purple gentian mixed in.

I am intensely happy here... It is such a treat to sit in a meadow, listen to the cowbells, smell the flowers, and of course see the beautiful mountains!

Where the snow has recently melted we find hundreds of blooming snowbells shivering in the wind.

There is so much life in these alpine meadows, just listen to all the insects buzzing around!

So many beautiful flowers to see — mountain violets, the stemless gentian, mountain arnica, the alpine forget-me-not, bellflowers, the list goes on and on and on...

Having visited Switzerland since my early childhood, I enjoy a special connection with the place. When I was growing up I always imagined I would marry a Swiss farmer!

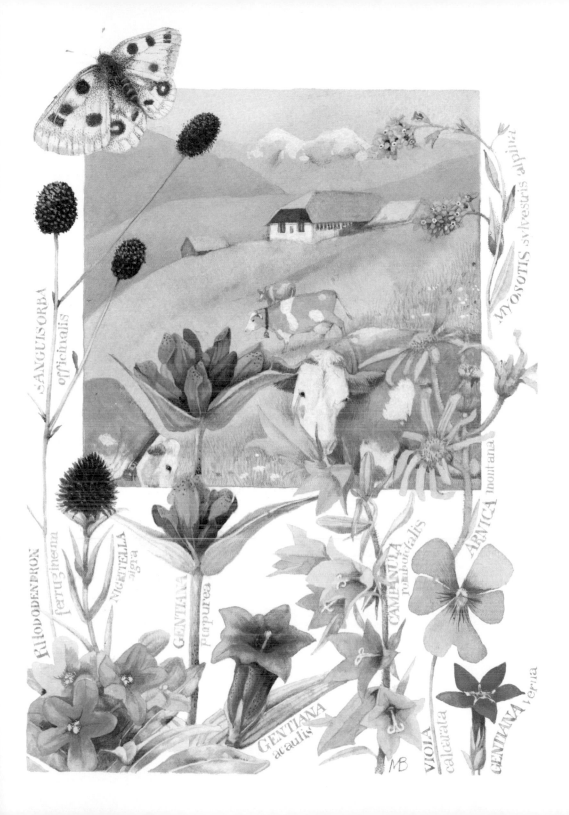

SANGUISORBA officinalis

MYOSOTIS sylvestris alpina

RHODODENDRON ferrugineum

NIGRITELLA nigra

GENTIANA purpurea

CAMPANULA rhomboidalis

ARNICA montana

GENTIANA acaulis

VIOLA calcarata

GENTIANA verna

MB

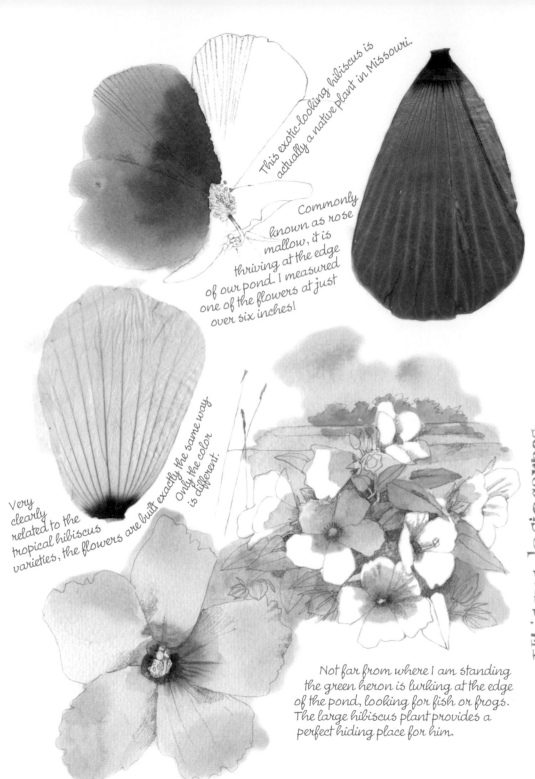

This exotic-looking hibiscus is actually a native plant in Missouri.

Commonly known as rose mallow, it is thriving at the edge of our pond. I measured one of the flowers at just over six inches!

Very clearly related to the tropical hibiscus varieties, the flowers are built exactly the same way. Only the color is different.

Not far from where I am standing the green heron is lurking at the edge of the pond, looking for fish or frogs. The large hibiscus plant provides a perfect hiding place for him.

Hibiscus lasiocarpos

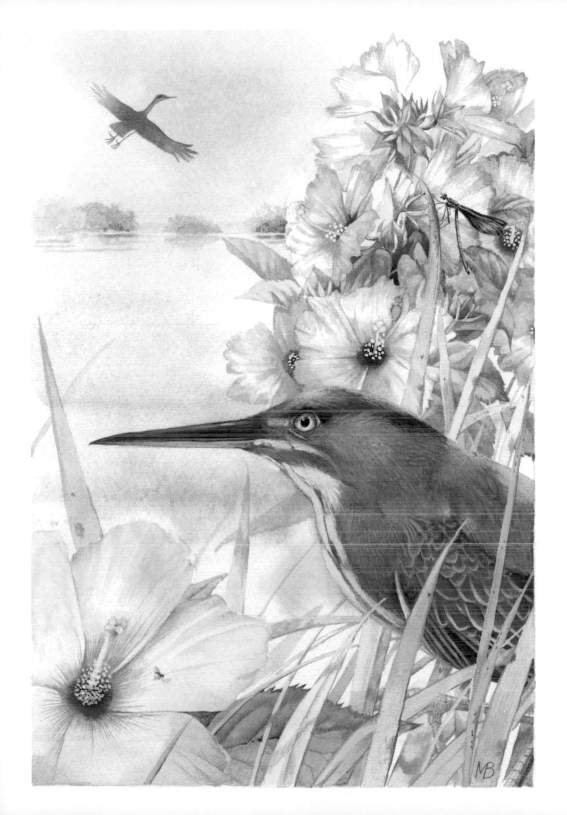

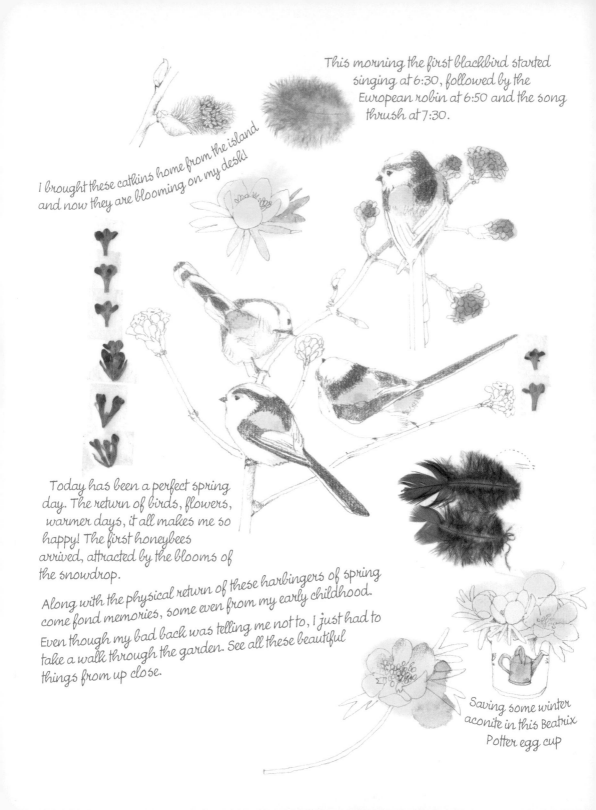

This morning the first blackbird started singing at 6:30, followed by the European robin at 6:50 and the song thrush at 7:30.

I brought these catkins home from the island and now they are blooming on my desk!

Today has been a perfect spring day. The return of birds, flowers, warmer days, it all makes me so happy! The first honeybees arrived, attracted by the blooms of the snowdrop.

Along with the physical return of these harbingers of spring come fond memories, some even from my early childhood. Even though my bad back was telling me not to, I just had to take a walk through the garden. See all these beautiful things from up close.

Saving some winter aconite in this Beatrix Potter egg cup

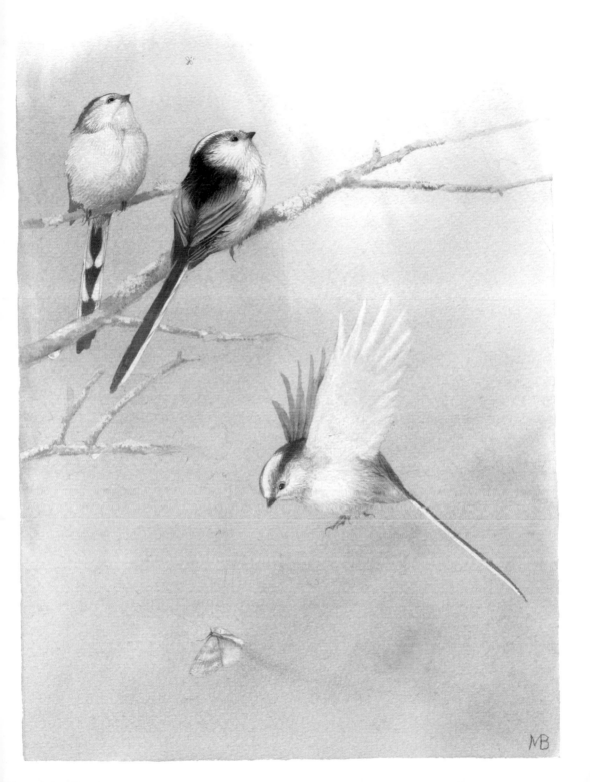

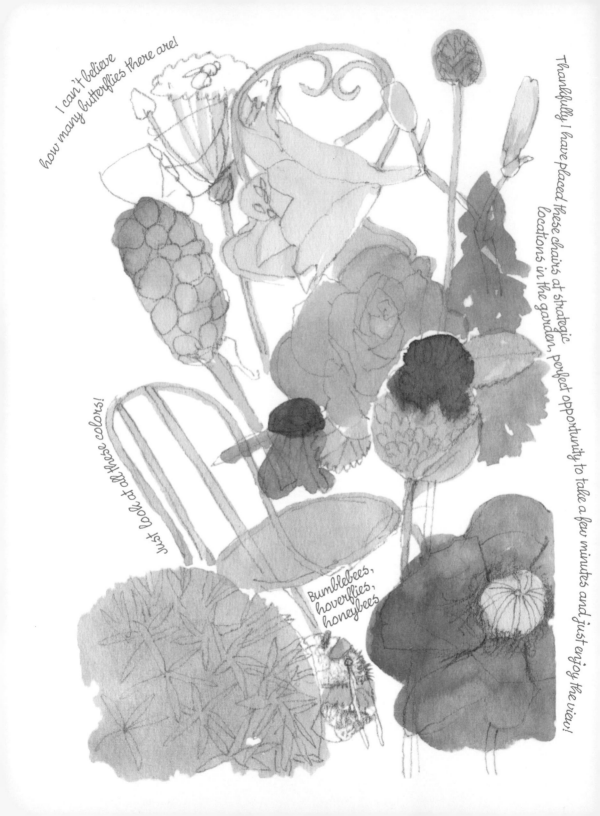

I can't believe how many butterflies there are!

Thankfully I have placed these chairs at strategic locations in the garden, perfect opportunity to take a few minutes and just enjoy the view!

Just look at all these colors!

Bumblebees, hoverflies, honeybees

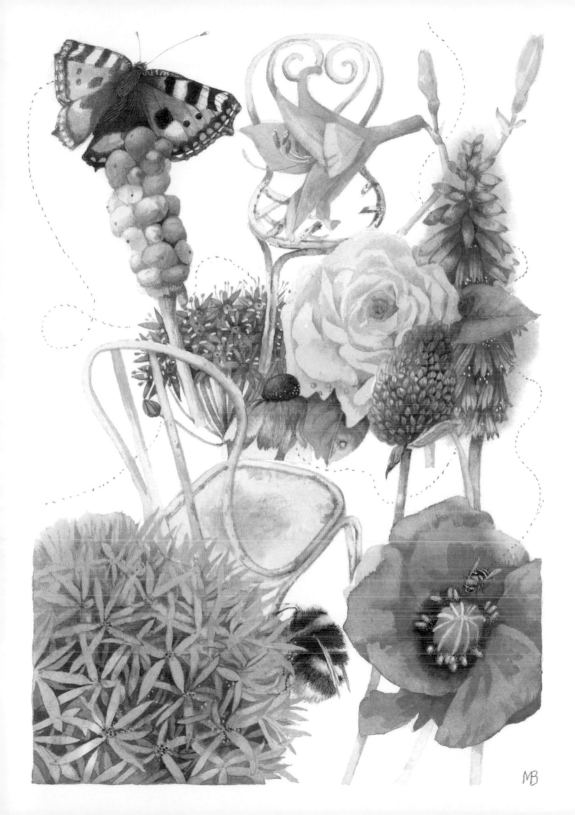

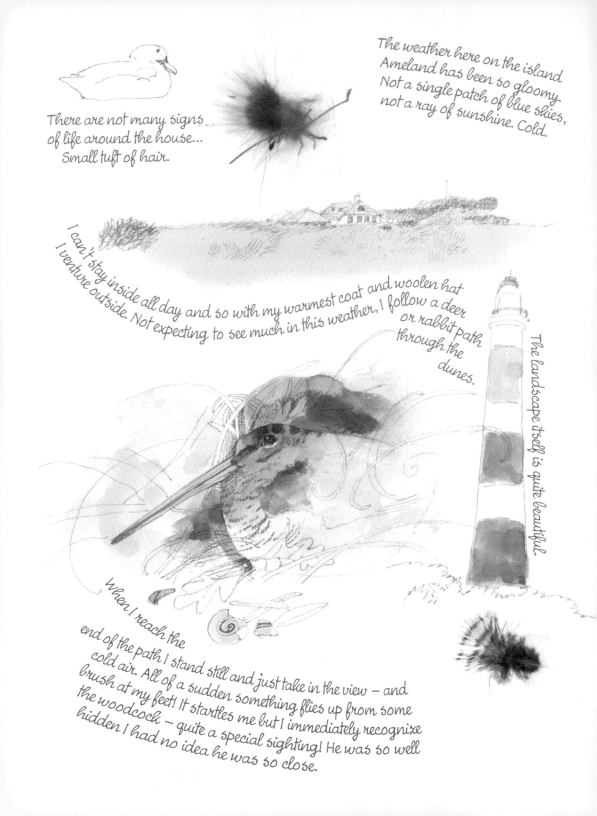

There are not many signs of life around the house... Small tuft of hair.

The weather here on the island Ameland has been so gloomy. Not a single patch of blue skies, not a ray of sunshine. Cold.

I can't stay inside all day and so with my warmest coat and woolen hat I venture outside. Not expecting to see much in this weather, I follow a deer or rabbit path through the dunes.

The landscape itself is quite beautiful.

When I reach the end of the path I stand still and just take in the view — and cold air. All of a sudden something flies up from some brush at my feet! It startles me but I immediately recognize the woodcock — quite a special sighting! He was so well hidden I had no idea he was so close.

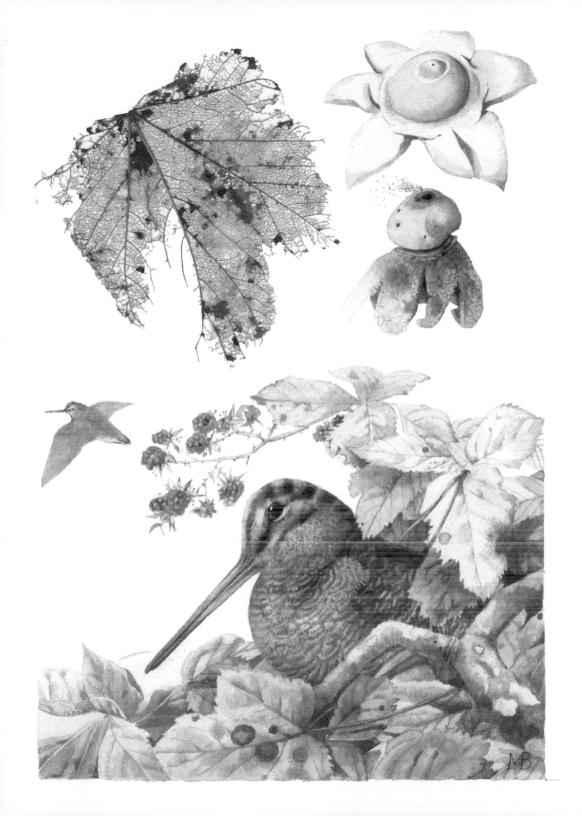

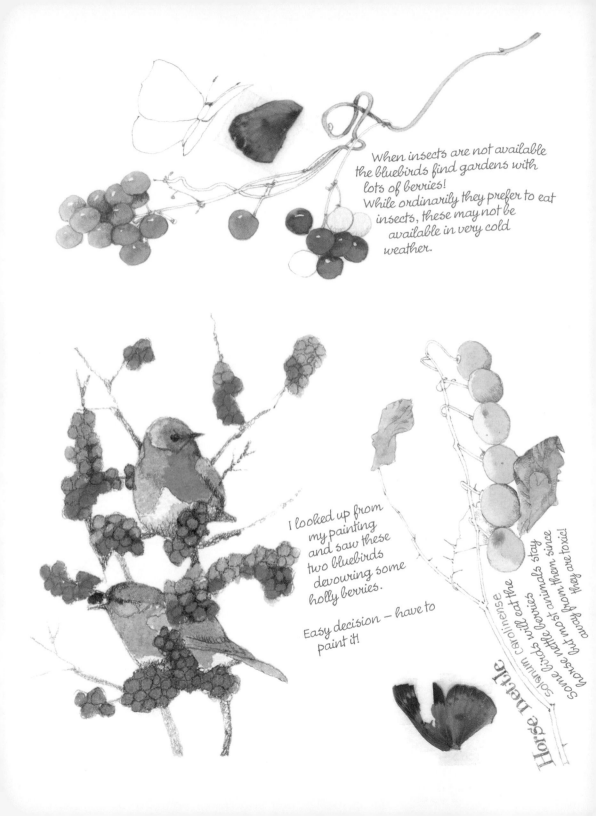

When insects are not available the bluebirds find gardens with lots of berries!
While ordinarily they prefer to eat insects, these may not be available in very cold weather.

I looked up from my painting and saw these two bluebirds devouring some holly berries.

Easy decision — have to paint it!

Horse Nettle
Solanum carolinense

Some birds will eat the horse nettle berries since most animals stay away from them since they are toxic!

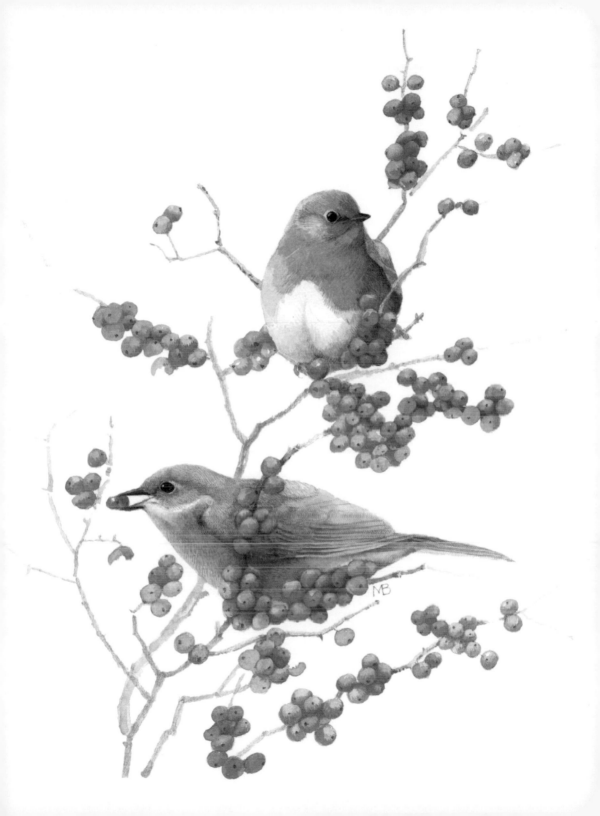

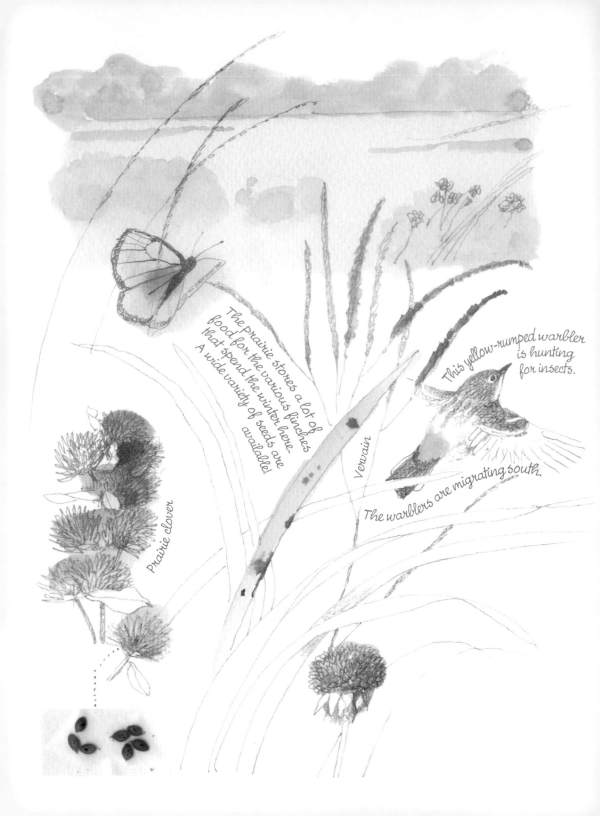

The prairie stores a lot of food for the various finches that spend the winter here. A wide variety of seeds are available!

This yellow-rumped warbler is hunting for insects.

The warblers are migrating south.

Vervain

Prairie clover

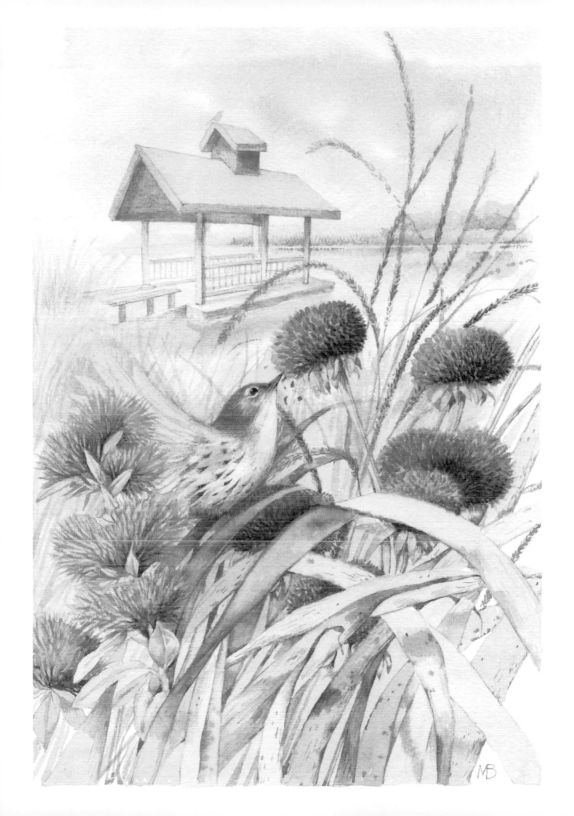

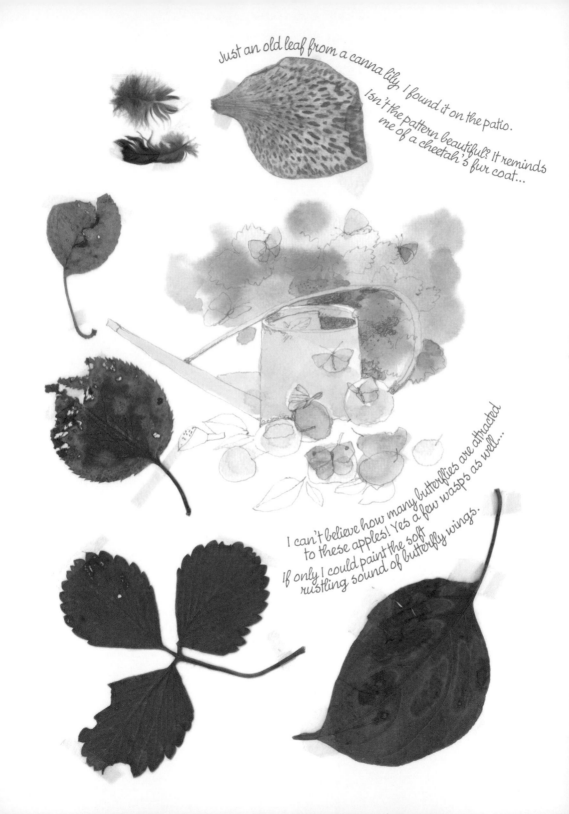

Just an old leaf from a canna lily, I found it on the patio. Isn't the pattern beautiful? It reminds me of a cheetah's fur coat...

I can't believe how many butterflies are attracted to these apples! Yes a few wasps as well... If only I could paint the soft rustling sound of butterfly wings.

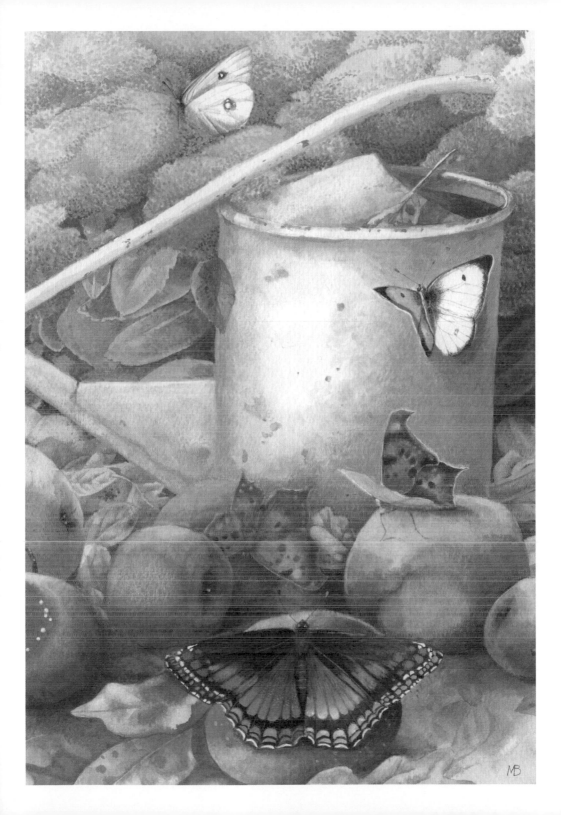

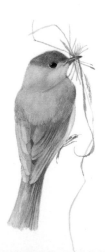

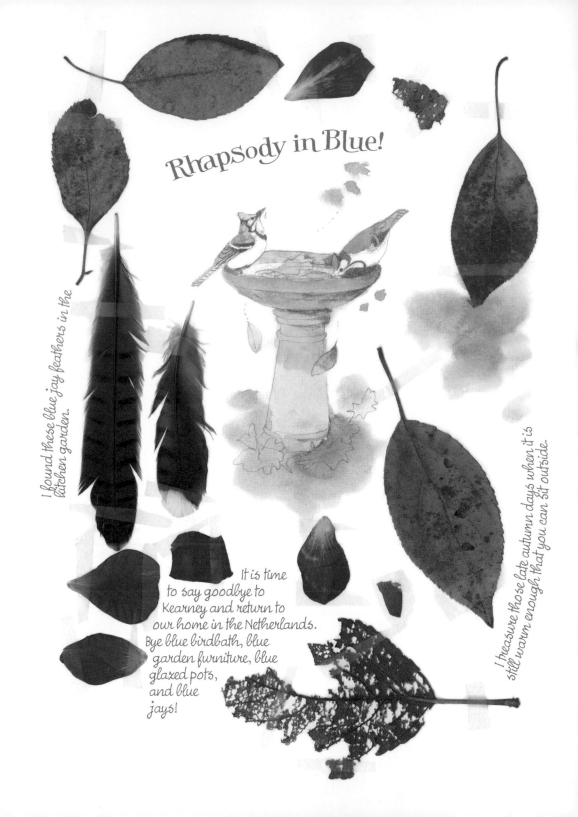

Rhapsody in Blue!

I found these blue jay feathers in the kitchen garden.

It is time
to say goodbye to
Kearney and return to
our home in the Netherlands.
Bye blue birdbath, blue
garden furniture, blue
glazed pots,
and blue
jays!

I treasure those late autumn days when it is still warm enough that you can sit outside.

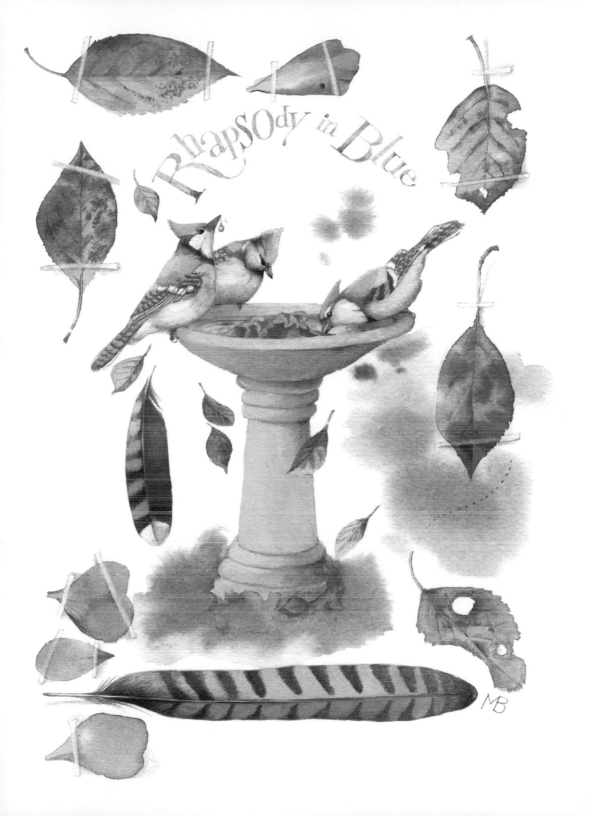

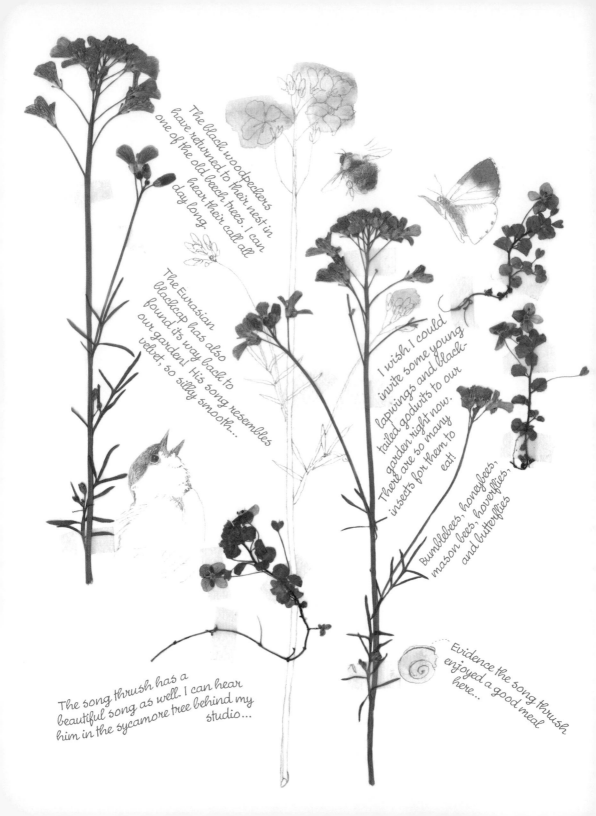

The black woodpeckers have returned to their nest in one of the old beech trees. I can hear their call all day long.

The Eurasian blackcap has also found it's way back to our garden! His song resembles velvet, so silly smooth...

I wish I could invite some young lapwings and black-tailed godwits to our garden right now. There are so many insects for them to eat!

Bumblebees, honeybees, mason bees, hoverflies, and butterflies

The song thrush has a beautiful song as well. I can hear him in the sycamore tree behind my studio...

Evidence the song thrush enjoyed a good meal here...

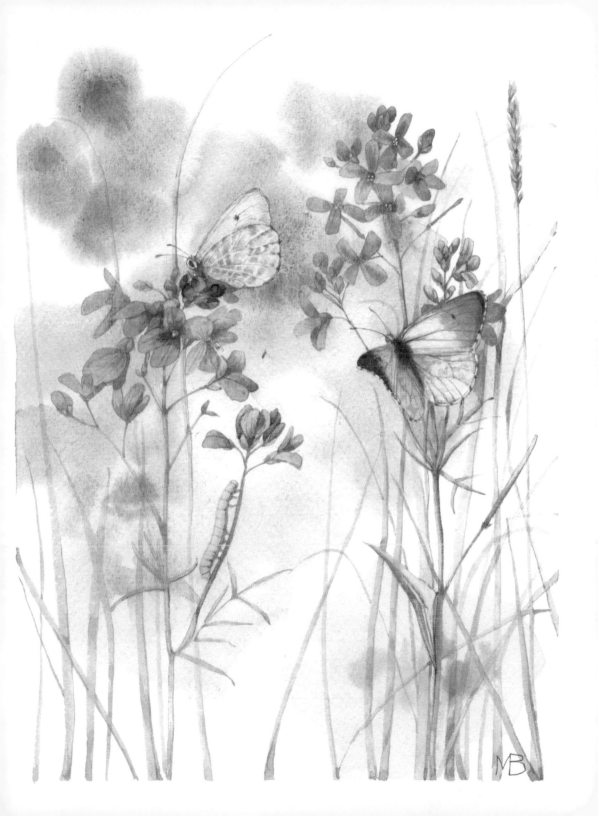

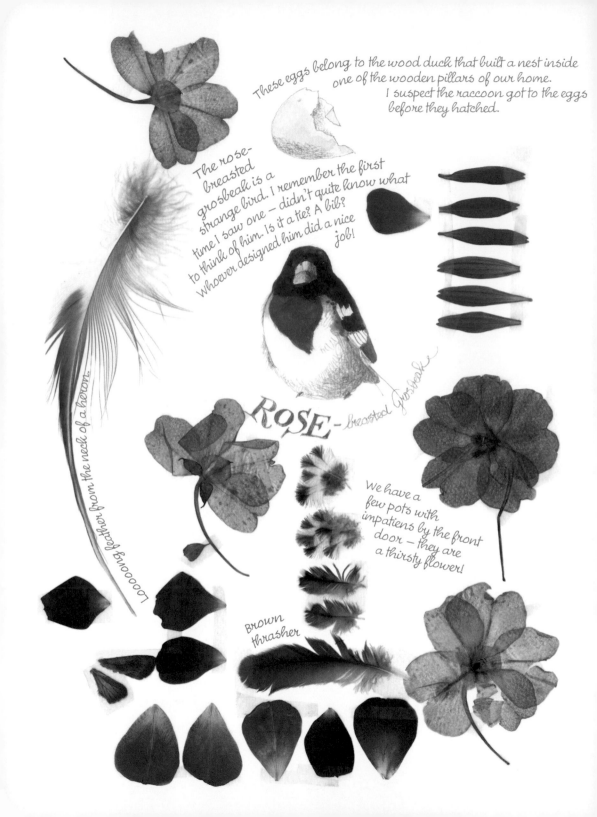

These eggs belong to the wood duck that built a nest inside one of the wooden pillars of our home. I suspect the raccoon got to the eggs before they hatched.

The rose-breasted grosbeak is a strange bird. I remember the first time I saw one — didn't quite know what to think of him. Is it a tie? A bib? whoever designed him did a nice job!

Loooooong feather from the neck of a heron.

ROSE - breasted Grosbeak

We have a few pots with impatiens by the front door — they are a thirsty flower!

Brown thrasher

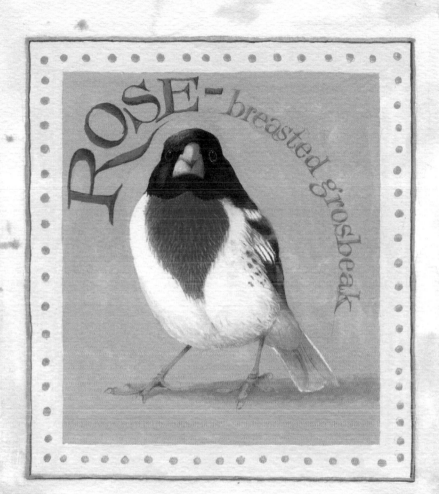

ROSE- breasted grosbeak

MB

ROSE

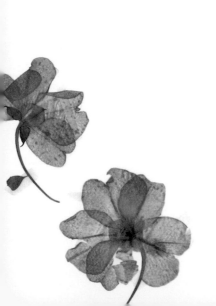

Remnants of the tiny earthstar

At least in the Netherlands there is no better place to go birding than the Wadden Sea, located along the northern coastline of the Netherlands. When the tide is low, birds find an abundance of food on the tidal flats. Any time we are on the island Ameland we make sure to drive along the dikes on the Wadden Sea-side of the island.

Geastrum minimum

This European robin has been hopping around the garden near the house all day.

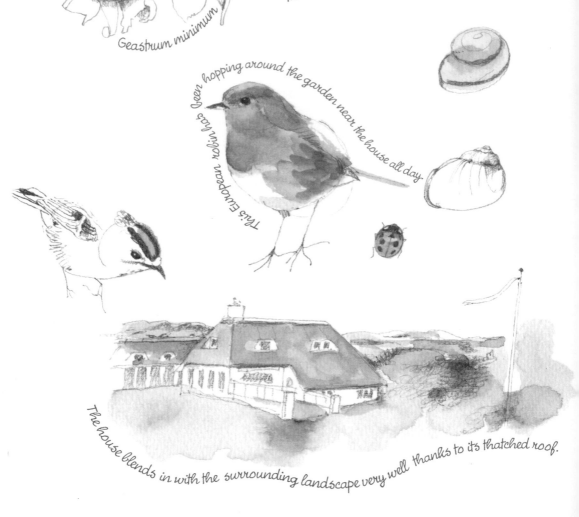

The house blends in with the surrounding landscape very well thanks to its thatched roof.

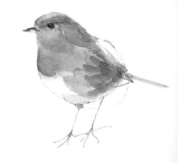

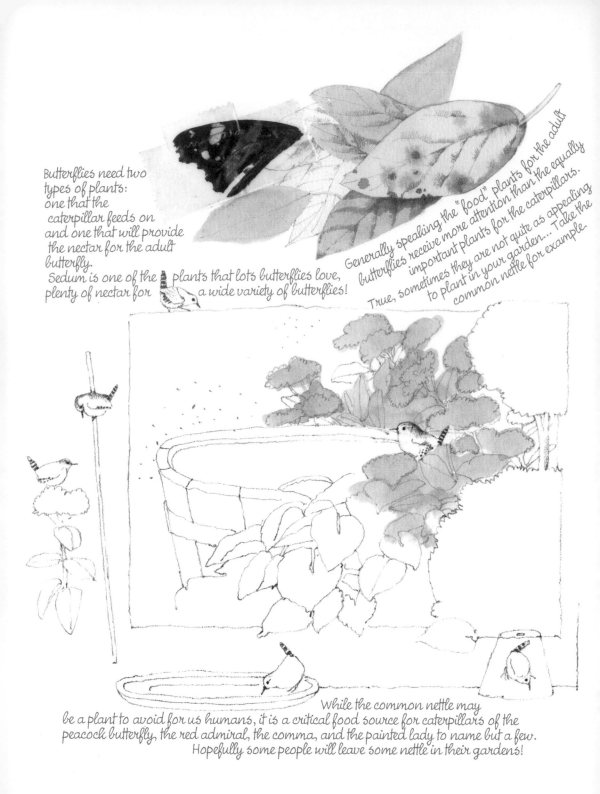

Butterflies need two types of plants: one that the caterpillar feeds on and one that will provide the nectar for the adult butterfly.
Sedum is one of the plants that lots butterflies love, plenty of nectar for a wide variety of butterflies!

Generally speaking the "food" plants for the adult butterflies receive more attention than the equally important plants for the caterpillars. True, sometimes they are not quite as appealing to plant in your garden... Take the common nettle for example.

While the common nettle may be a plant to avoid for us humans, it is a critical food source for caterpillars of the peacock butterfly, the red admiral, the comma, and the painted lady to name but a few. Hopefully some people will leave some nettle in their gardens!

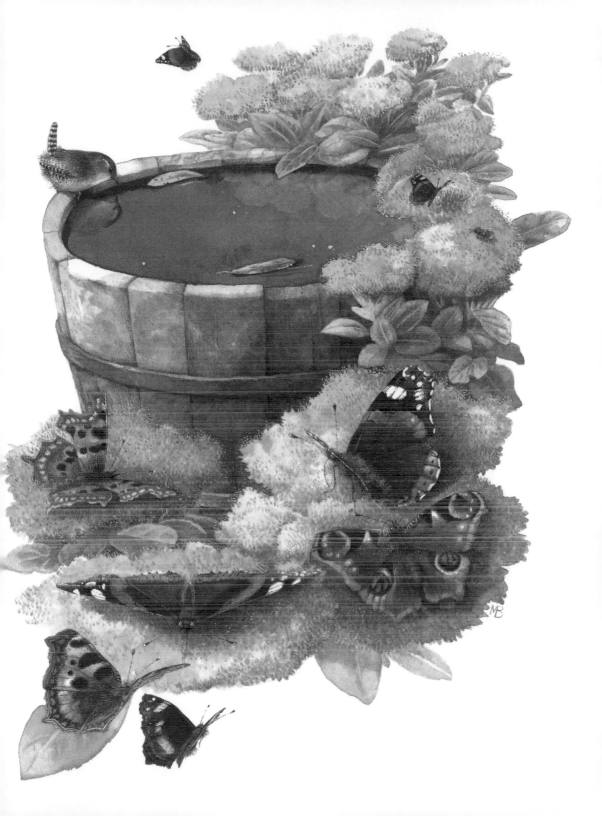

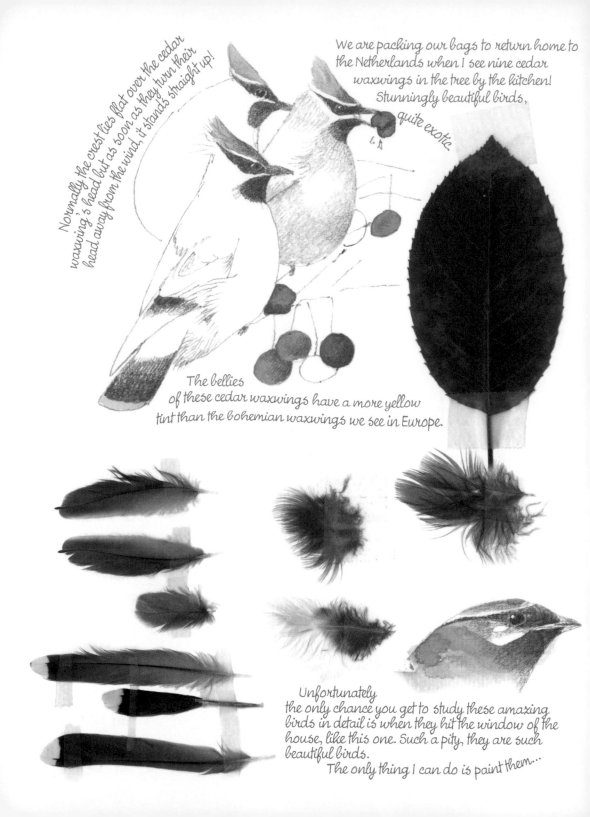

Normally the crest lies flat over the cedar waxwing's head but as soon as they turn their head away from the wind, it stands straight up!

We are packing our bags to return home to the Netherlands when I see nine cedar waxwings in the tree by the kitchen! Stunningly beautiful birds, quite exotic.

The bellies of these cedar waxwings have a more yellow tint than the bohemian waxwings we see in Europe.

Unfortunately the only chance you get to study these amazing birds in detail is when they hit the window of the house, like this one. Such a pity, they are such beautiful birds.
 The only thing I can do is paint them...

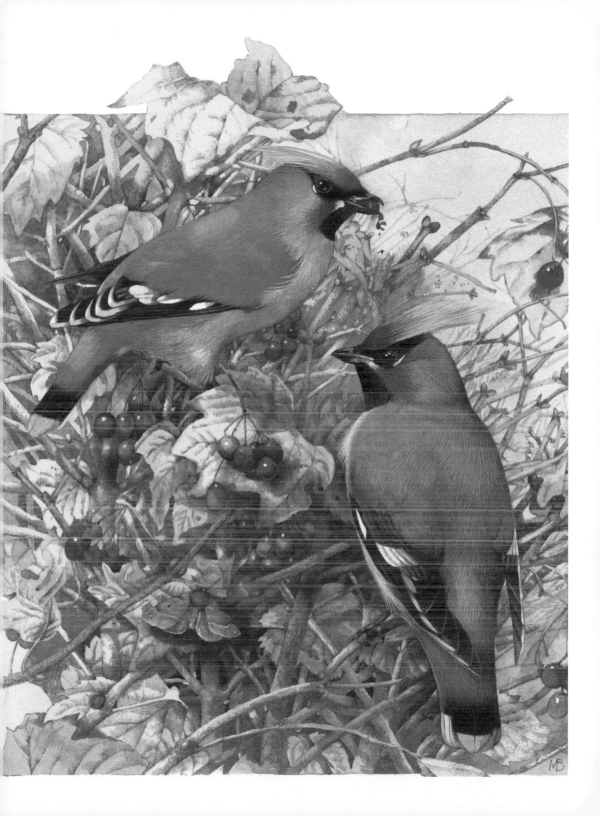

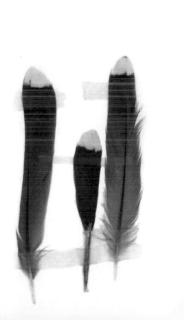

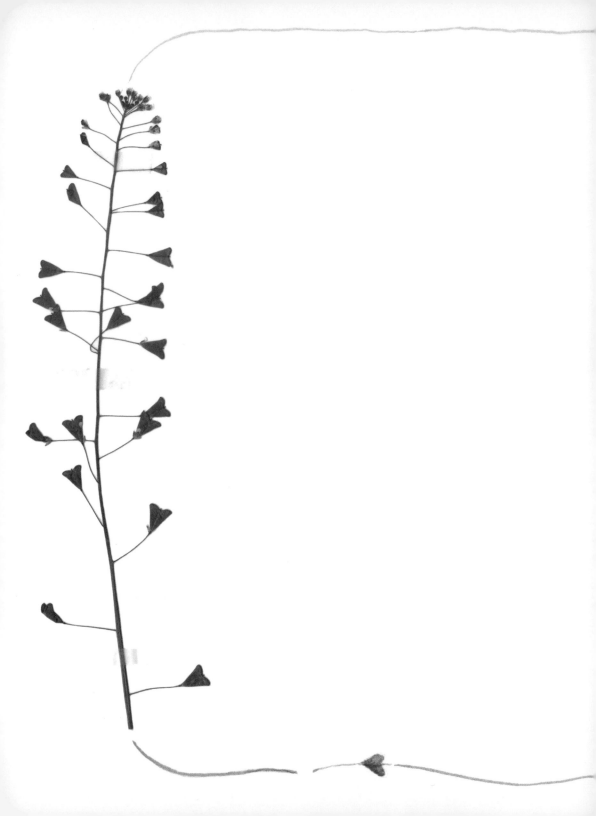

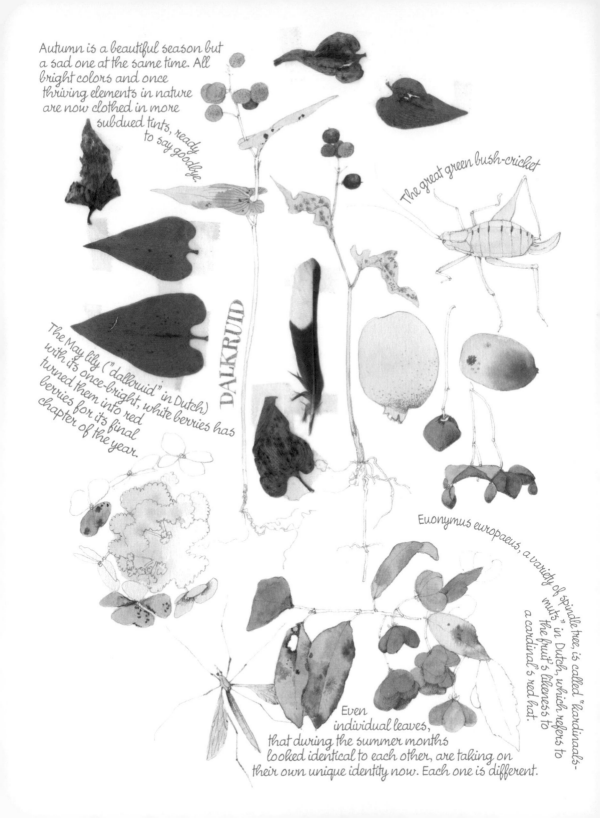

Autumn is a beautiful season but a sad one at the same time. All bright colors and once thriving elements in nature are now clothed in more subdued tints, ready to say goodbye.

The great green bush-cricket

DALKRUID

The May lily ("dalkruid" in Dutch) with it's once-bright, white berries has turned them into red berries for it's final chapter of the year.

Euonymus europaeus, a variety of spindle tree, is called "kardinaals-muts" in Dutch, which refers to the fruit's likeness to a cardinal's red hat.

Even individual leaves, that during the summer months looked identical to each other, are taking on their own unique identity now. Each one is different.

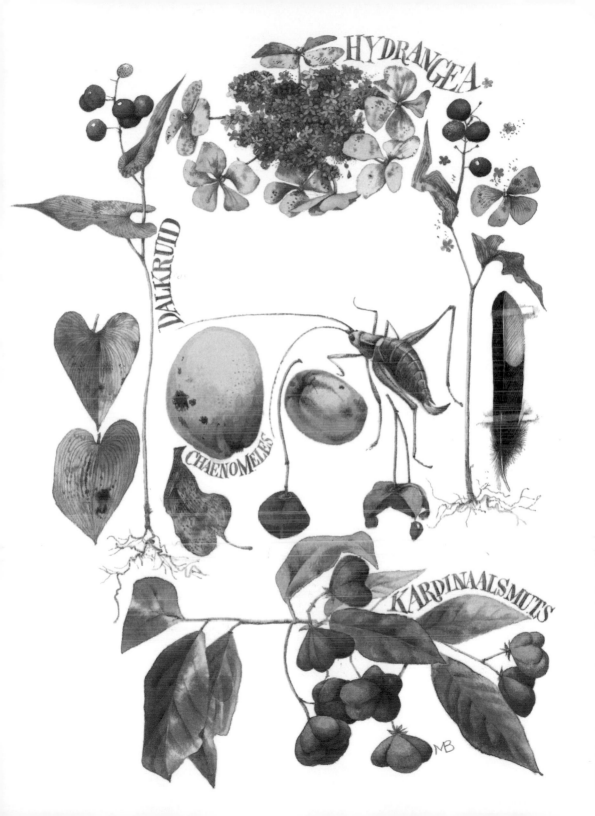

HYDRANGEA

DALKRUID

CHAENOMELES

KARDINAALSMUTS

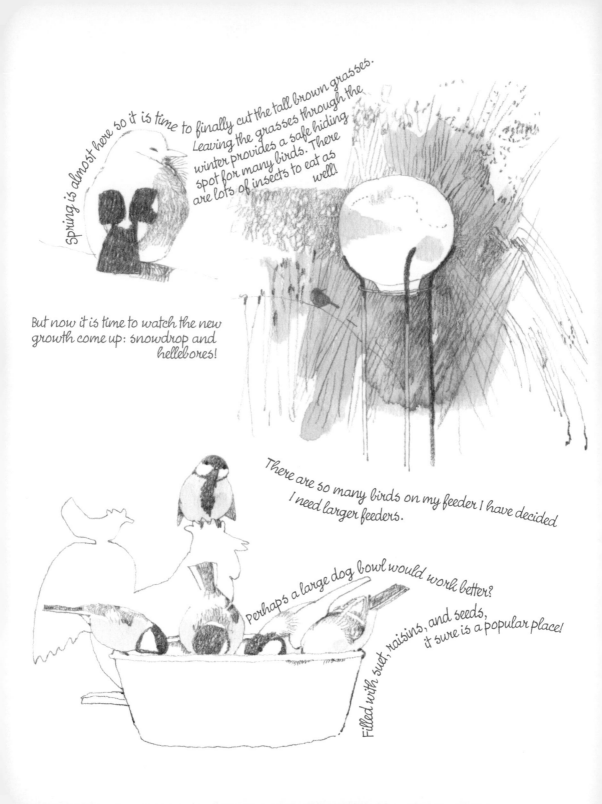

Spring is almost here so it is time to finally cut the tall brown grasses. Leaving the grasses through the winter provides a safe hiding spot for many birds. There are lots of insects to eat as well!

But now it is time to watch the new growth come up: snowdrop and hellebores!

There are so many birds on my feeder I have decided I need larger feeders.

Perhaps a large dog bowl would work better?

Filled with suet, raisins, and seeds, it sure is a popular place!

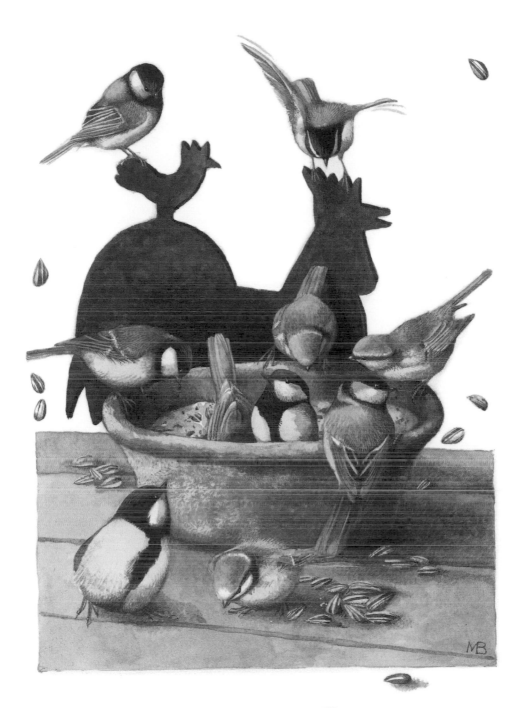

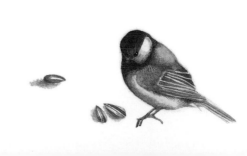

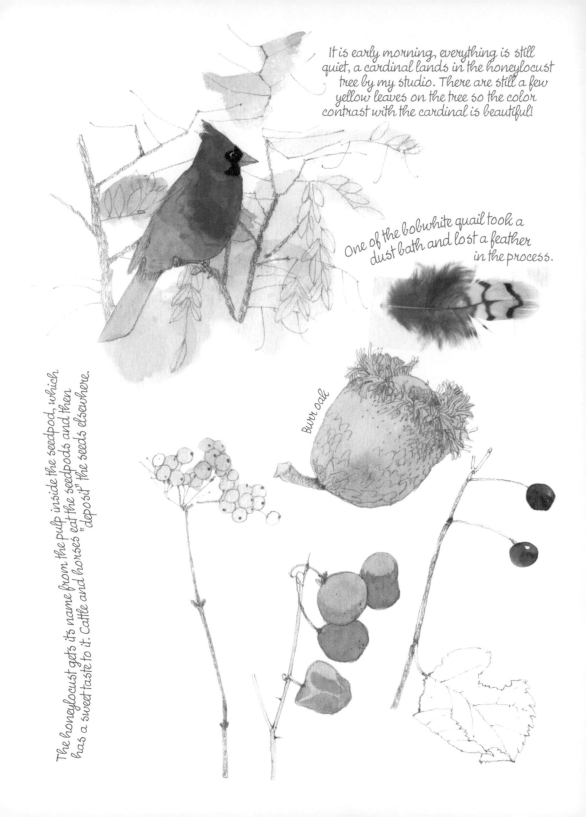

It is early morning, everything is still quiet, a cardinal lands in the honeylocust tree by my studio. There are still a few yellow leaves on the tree so the color contrast with the cardinal is beautiful!

One of the bobwhite quail took a dust bath and lost a feather in the process.

Burr oak

The honeylocust gets its name from the pulp inside the seedpod, which has a sweet taste to it. Cattle and horses eat the seedpods and then "deposit" the seeds elsewhere.

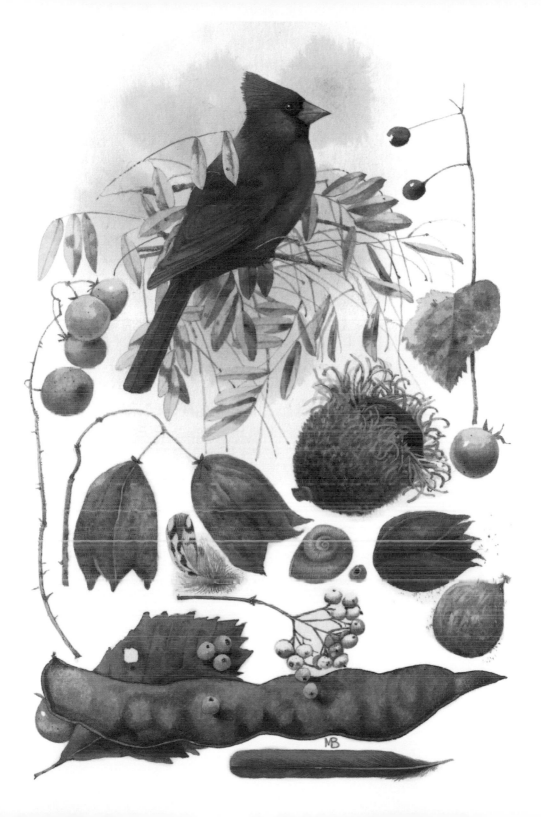

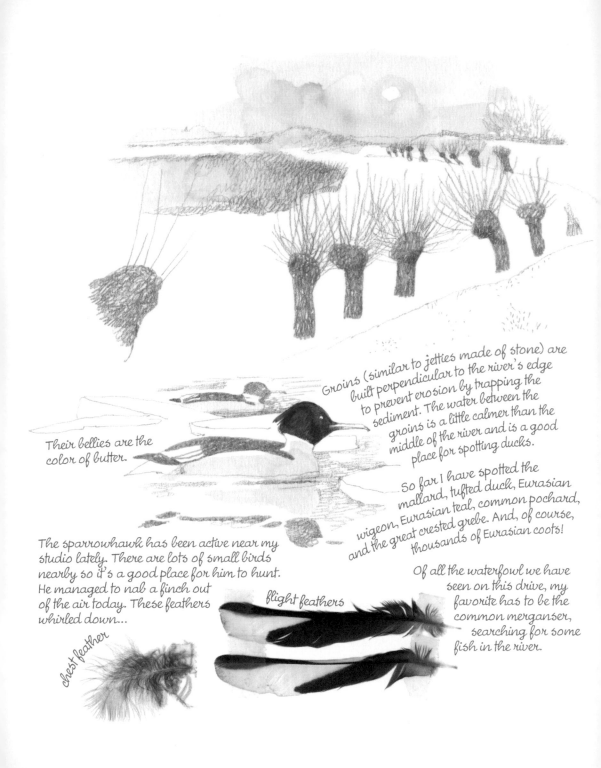

Their bellies are the color of butter.

Groins (similar to jetties made of stone) are built perpendicular to the river's edge to prevent erosion by trapping the sediment. The water between the groins is a little calmer than the middle of the river and is a good place for spotting ducks.

So far I have spotted the mallard, tufted duck, Eurasian wigeon, Eurasian teal, common pochard, and the great crested grebe. And, of course, thousands of Eurasian coots!

The sparrowhawk has been active near my studio lately. There are lots of small birds nearby so it's a good place for him to hunt. He managed to nab a finch out of the air today. These feathers whirled down...

chest feather

flight feathers

Of all the waterfowl we have seen on this drive, my favorite has to be the common merganser, searching for some fish in the river.

ECHINACEA PURPUREA

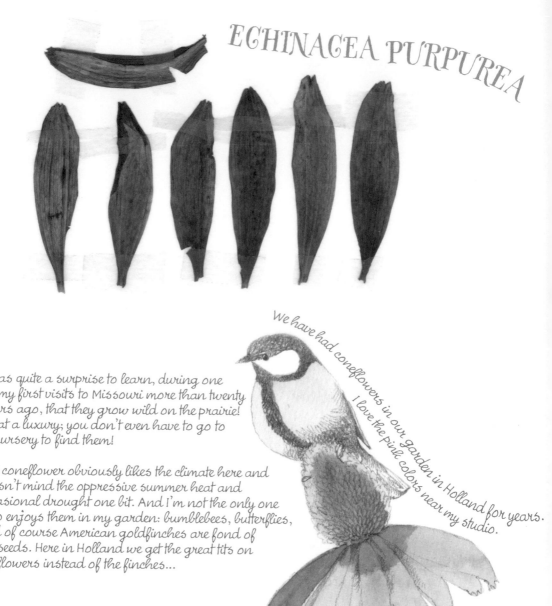

It was quite a surprise to learn, during one of my first visits to Missouri more than twenty years ago, that they grow wild on the prairie! What a luxury; you don't even have to go to a nursery to find them!

The coneflower obviously likes the climate here and doesn't mind the oppressive summer heat and occasional drought one bit. And I'm not the only one who enjoys them in my garden: bumblebees, butterflies, and of course American goldfinches are fond of the seeds. Here in Holland we get the great tits on the flowers instead of the finches...

We have had coneflowers in our garden in Holland for years. I love the pink colors near my studio.

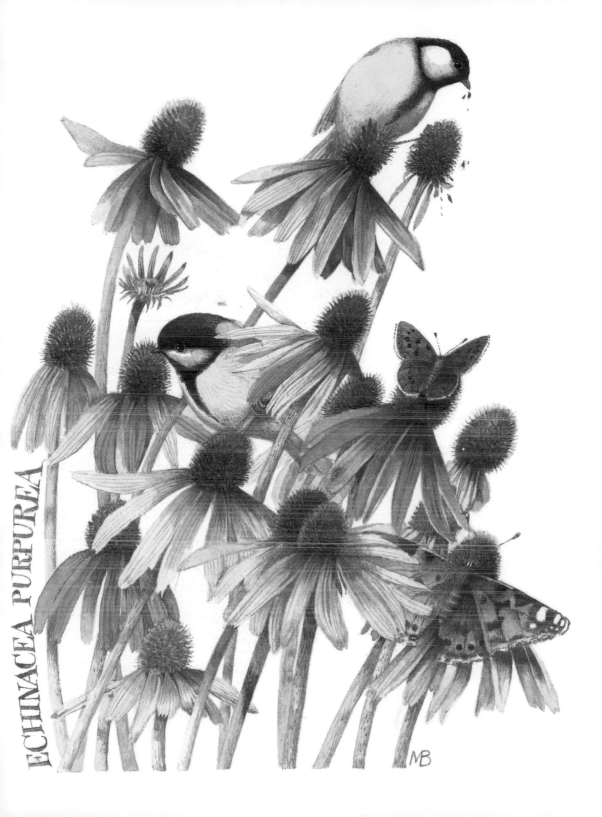

ECHINACEA PURPUREA

MB

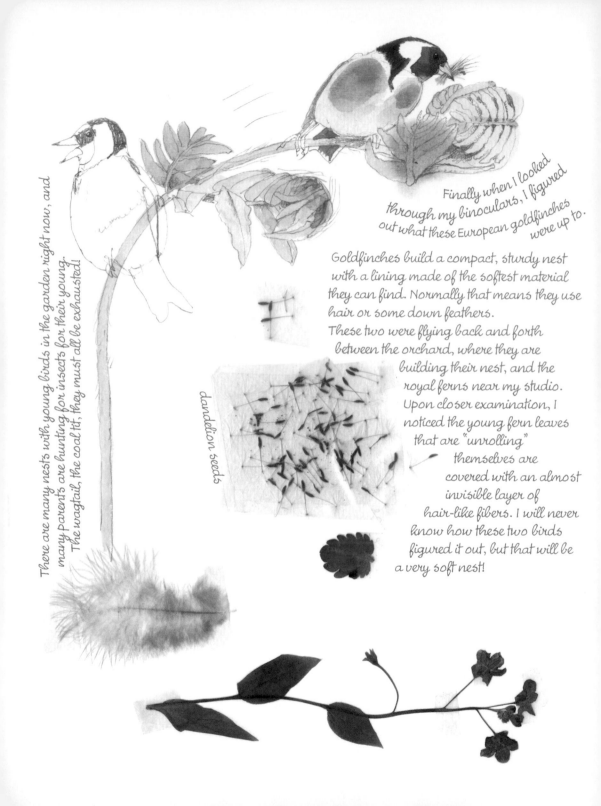

Finally when I looked through my binoculars, I figured out what these European goldfinches were up to.

Goldfinches build a compact, sturdy nest with a lining made of the softest material they can find. Normally that means they use hair or some down feathers.

These two were flying back and forth between the orchard, where they are building their nest, and the royal ferns near my studio. Upon closer examination, I noticed the young fern leaves that are "unrolling" themselves are covered with an almost invisible layer of hair-like fibers. I will never know how these two birds figured it out, but that will be a very soft nest!

There are many nests with young birds in the garden right now, and many parents are hunting for insects for their young. The wagtail, the coal tit, they must all be exhausted!

dandelion seeds

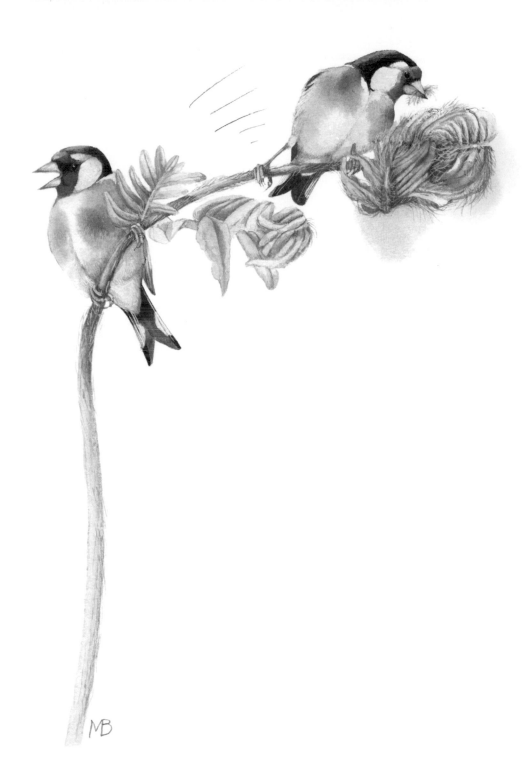

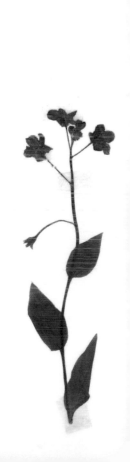

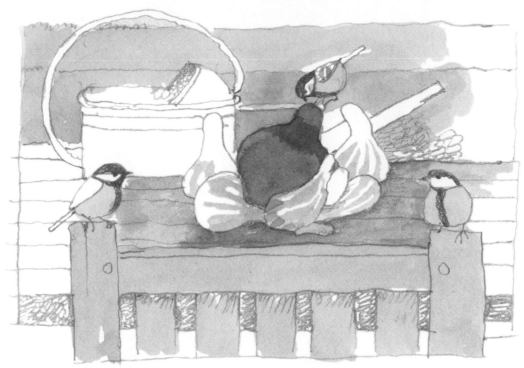

From my kitchen window, I see two great tits sitting on the chair and a third on top of a gourd. Usually when I put something outside they know there is something to eat: suet, sunflower seeds, peanut butter, fruit... They're probably wondering where I have hidden their food this time!

My daughter Sanna grew so many gourds in her garden that she gave me quite a few of them to decorate the garden.

They look great on the otherwise-empty tables!

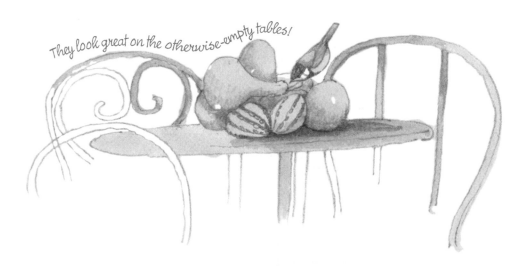

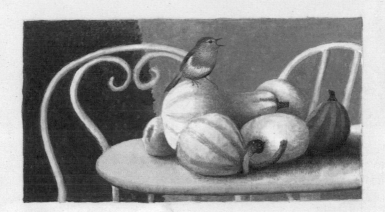

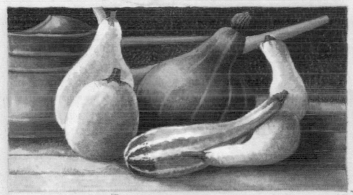

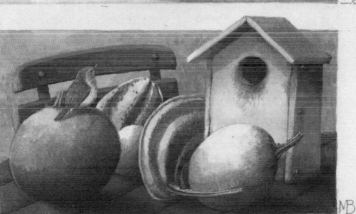

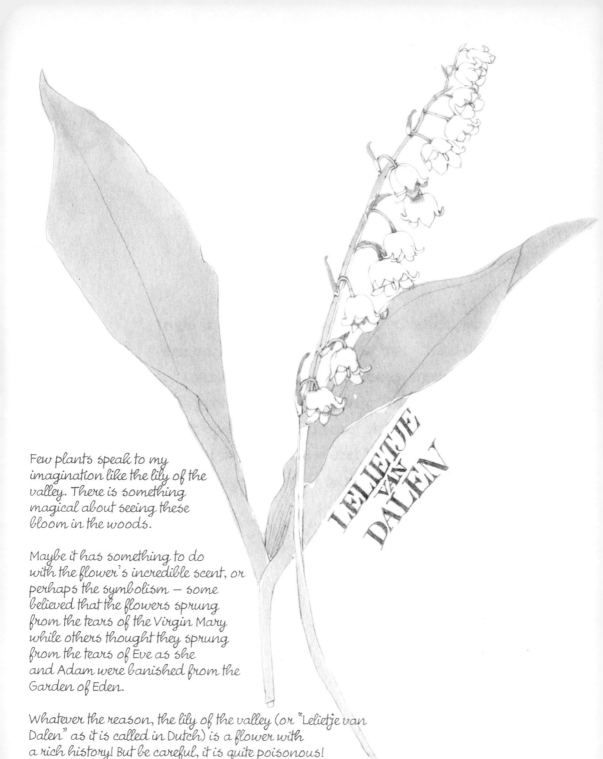

LELIETJE VAN DALEN

Few plants speak to my imagination like the lily of the valley. There is something magical about seeing these bloom in the woods.

Maybe it has something to do with the flower's incredible scent, or perhaps the symbolism — some believed that the flowers sprung from the tears of the Virgin Mary while others thought they sprung from the tears of Eve as she and Adam were banished from the Garden of Eden.

Whatever the reason, the lily of the valley (or "Lelietje van Dalen" as it is called in Dutch) is a flower with a rich history! But be careful, it is quite poisonous!

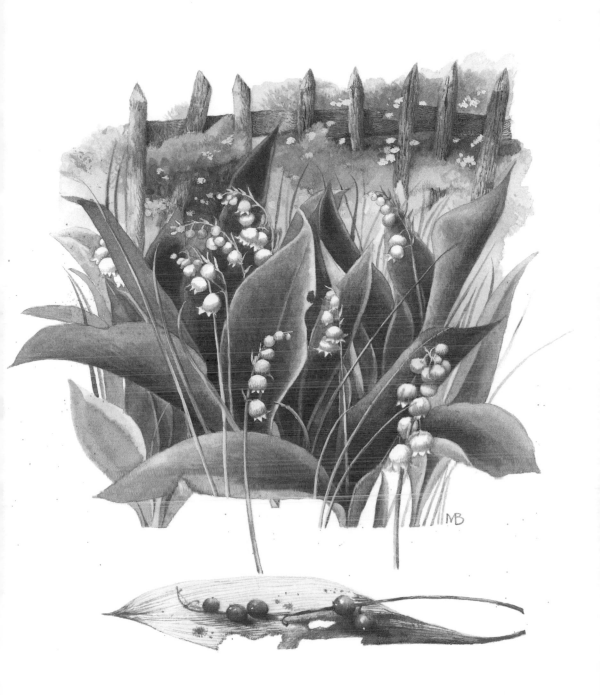

Andrews McMeel Publishing
a division of Andrews McMeel Universal
1130 Walnut Street, Kansas City, Missouri 64106

www.andrewsmcmeel.com

18 19 20 21 22 RLP 10 9 8 7 6 5 4 3 2 1

ISBN: 978-1-4494-9596-1

Library of Congress Control Number: 2018959713

Editor: Karen Paulic
Art Director/Designer: Julie Barnes
Production Editor: Julie Railsback
Production Manager: Tamara Haus

ATTENTION: SCHOOLS AND BUSINESSES
Andrews McMeel books are available at quantity discounts
with bulk purchase for educational, business, or sales promotional use.
For information, please e-mail the Andrews McMeel Publishing
Special Sales Department: specialsales@amuniversal.com.